Museum Retailing

For almost 20 years Andrew Andoniadis has shared
his retail experience with museum store professionals
in many perceptive and practical articles, seminars
and conference presentations.

We felt it would be both valuable and appropriate
to bring together a selection of his work into
a single, accessible volume. We are grateful to
Andrew for agreeing to this – and for his willingness
to select, revise, and where necessary update,
all the articles presented here.

Museum Retailing

A Handbook of Strategies for Success

Selected Articles by Andrew Andoniadis

MUSEUMSETC | EDINBURGH

Museum store retailing is both different and similar to commercial retail. The similarities of success include treating the customer well, providing products of value and interest and running the enterprise like a business.

The differences are exciting. A successful museum store does good while doing well. For many institutions the revenue generated by the store is critical to the financial stability of the museum and benefits multiple constituencies including visitors, students, volunteers, members, researchers and staff. The product selection is a great resource for continuing education and an outlet for the creativity of authors and artisans. And what excitement there is in seeing young students excited by a museum visit and being able to transport some of that excitement back to their homes.

The chapters in this book were originally written for publication in professional magazines, particularly the Museum Store Association's *Museum Store*. I am grateful to the Association for giving their blessing to their being collected in this volume and for their efforts on behalf of cultural commerce around the globe. All the content has been reviewed, revised, and where necessary updated, for inclusion here.

This book has been intentionally designed so that it can either be read from cover to cover or, alternatively, be quickly and easily consulted for help with a specific issue or dilemma. In order that key chapters can be read individually and still provide cogent guidance, similar recommendations will, where relevant, be found in more than one chapter.

Although my illustrations are primarily from North

America, I have also drawn on my experience with museum store professionals in Europe and Australasia, so that – specifics such as tax and legal issues apart – I've tried to ensure that the principles and practices proposed will be equally applicable to any museum, gallery, heritage or cultural organisation – wherever they operate.

It has been my privilege and great fortune to work on over three hundred museum store projects. Especially gratifying is the chance to meet dedicated museum administrators, get tours of collections led by curators and to work with the educators associated with these institutions. But my greatest gratitude is reserved for the dedicated, extraordinarily talented, multi-tasking, overworked, volunteer and paid managers and staffs of the stores with whom I have worked and can call friends.

A couple of general notes. Most of the fundamental principles in the book can be categorized as part of the *art* or *science* of museum store retailing. The art includes topics such as product selection, merchandising, display, customer service, layout and design. The science are the numbers such as for record-keeping, retail pricing and inventory management.

Finally, I'd like to define how two words are used throughout. *Merchandising* is where products are placed from which the customer makes their selection. *Displays* are a collection of products, often from several departments, creating a theme to focus the customer's attention on the selected products.

ADMINISTRATION

How Do I Measure Success?

How do I measure my store's success?

There are both economic and non-economic gauges of success for museum stores. From my point of view the most successful stores recognize that maximizing profitability is the most important goal for the store because it is a reflection of the results of all aspects of retail management. It is also my experience that continuing education and community outreach goals are not only fully compatible with profitability but enhance the results.

I believe it is also true, if continuing education and community outreach goals are placed ahead of profitability, all three segments will not reach their full potential.

There are three non-economic gauges of success for a museum store. First, since store salespeople often have more contact with visitors than any other museum personnel, the quality of that interaction impacts on the success of the store and the impression of the museum.

Second, the visit to the store is usually part of the last and lasting impression on the museum visitor. The quality of this impression also reflects on the success of the store and museum.

Finally, the store is the best source of continuing education. In this regard, product selection impacts the entire image of the museum and is an integral part of determining the success of the store.

The Art and Science of Retailing

Surveys consistently tell us the museum store is an integral part of the visitor's experience in a museum. This finding should provide the impetus for museums to enhance the visitor's experience, extend continuing education for visitors of all types and increase revenue by providing an attractive retail presence.

Museum retailing is a combination of art and science. The art is present in subjective product selection decisions, the display and merchandising of products and the layout and design of the store. These are the factors that most directly affect the visitor/customer. The science is represented by numbers, primarily generated by the reaction of the visitor/customer to the retail presence. These include financial calculations and the measurement and evaluation of individual product and category sales. Let's look at each of these factors separately and in some detail to see how they affect today's museum visitor and museum store customer.

THE ART OF RETAIL

Continuing education

The visitor is learning, experiencing and experimenting while they visit the museum, but that process usually comes to an abrupt halt when they leave. If, before they leave the museum they stop in the store, you have the opportunity to provide books and other products that can extend the educational experience, in both time and distance, far beyond the museum visit. Surely, this meets one of the most important goals of every museum.

To take full advantage of this opportunity and avoid Unrelated Business Income Tax (UBIT) problems, the store product mix should relate directly to the mission and exhibits of the museum. The added advantage of this focus is that it will distinguish the museum store from generic gift shops and help to develop the store into a retail destination.

While some museum administrators may disagree with the prominence of a few of product categories below, museum store customers have voted with their pocketbooks, making these the categories that best connect with the visitor.

Individual museums can tailor their product selections any way they wish, but must realize the decisions have financial impact. For example, a museum may only want to sell books. That's fine. But that decision should be made with the full realization that it will probably limit revenue potential and, for sure, affect profitability.

Books are the heart of a museum store. It is the category that gives specific and implied seriousness to all the product selection. The book selection often makes the difference between a *museum store* and a *gift shop*. In addition, a strong book selection helps support the sale of higher-priced, higher-margin products by giving the customer the confidence that the higher price is supported by well-educated buying decisions.

A word of warning. Museums frequently print too many copies of self-published catalogs and books of little popular appeal. If you expect to sell these publications through the store, invite the store manager to comment on the probable public appeal of the publication, a reasonable retail price

and the quantity that can be reasonably expected to be sold through the store.

Jewelry: Simply put, mission-related jewelry is a high margin (helping to balance the often low margin for books), very popular product category with a wide range of retail prices that can generate significant revenue out of a small space. Jewelry appeals to buyers of all ages for personal and gift purchases.

Paper products from postcards and posters to historic reproductions and journals are popular because they are relatively inexpensive and conveniently transported. In addition, paper products can be easily customized to reflect the museum brand.

Apparel: T-shirts, sweatshirts, polos, hats and higher-priced logo jackets and other apparel are very popular. The reaction to T-shirts and sweatshirts should not be, I don't want T-shirts in my museum, it should be: I only want T-shirts with great, relevant graphics in the museum store.

Children's Products and Activity Kits: The quantity of children's-related products will vary with the level of visitation by children, but two finer points are universally important. First, even if the visitation is adult-oriented, parents and especially grandparents love to buy good quality children's products for their children and grandchildren. Second, if children are in the visitor mix in any way, I don't think there is a better product category than hands-on activity kits for meeting the continuing education goals of any museum. Whether it's beading kits based on First People designs,

science kits or an ant farm, it goes to the core of children learning.

There are, of course, many other product categories including two-and three-dimensional original and reproduction art, crafts, audio-visual and, depending on the mission of the institution, science kits or gardening supplies, but the above represent the core of most museum store revenue.

Proprietary Product: Across all product categories there is the opportunity to produce proprietary product that is unique to the institution. Some, like paper products and name drops on apparel and novelty items are easy and inexpensive. Others, like the three-dimensional reproductions of items from the collection are considerably more difficult and expensive. All these efforts however, are warmly received by the customer, tie the product to the mission of the institution and mitigate UBIT problems.

Interaction with the visitor

Along with docents and historical interpreters, the store staff often has the most interaction with the visitor. This interaction may range from questions unrelated to the museum about local restaurants and attractions, to those about products that complement areas of interest in the museum. Regardless of the nature of the interaction, the store staff becomes part of the human face and lasting impression of the museum.

For this reason the staff must be well-trained in customer

service, knowledgeable about exhibits and products, appropriately dressed and prominently identified as store staff with more visitor-friendly nametags than routine security badges.

THE SCIENCE OF RETAIL

Store evaluation

Although there are many financial formulas that can be used to evaluate the performance of a museum store, the most basic and revealing may be the following. Unfortunately, there is little standardization in how visitors are counted, store size measured, and accounting applied to revenue and expenses, so inter-museum comparisons are difficult and can be misleading. This does not, however, preclude museums from keeping track of these measurements for intra-institution measurement and evaluation.

Capture rate (percentage of visitors making a purchase)

$$\frac{\text{Number of Retail Transactions}}{\text{Number of Visitors}}$$

The location of the store within the institution, along with the look and feel of the space, product selection and retail pricing has the greatest impact.

Dollars per visitor

$$\frac{\text{Net Retail Sales}}{\text{Number of Visitors}}$$

The key to the value of this measurement is the consistency

of the methodology applied to visitor counts.

Dollars per customer

$$\frac{\text{Net Retail Sales}}{\text{Number of Retail Transactions}}$$

This may be the most revealing of all because it is the measurement based on those visitors who have crossed the threshold into the store and are reacting to the retail environment regardless of where the store is located or how they were counted.

Gross sales and dollars per square foot

Gross sales and dollars per square foot are traditional retail measurements but are unreliable for inter-store comparative purposes because of the counting and measuring difficulties noted above.

Inventory turnover

$$\frac{\text{Cost of Goods Sold}}{\text{Average Inventory}}$$

Turnover is the measurement of the efficient use of inventory dollars. The higher the turnover (within reason) the more frequently the same inventory dollars are reused throughout the year. The lower the turnover, the higher the average dollars invested in inventory. For cash-strapped museums this is an important fiscal measurement.

Open-to-Buy (OTB)

An OTB is a merchandise buying plan and the most important financial tool because it helps to manage inventory, which is the biggest expense category in any retail environment. All stores, regardless of size, should consistently use an OTB – period! When I have my consultant's hat on and I'm evaluating store performance, an inappropriately high inventory level is the most frequently encountered and devastating financial problem.

In summary, the museum store can be a multiple winning situation for the museum and its visitors. A good retail presence enhances the image of the museum, furthers continuing education, improves visitor satisfaction and increases discretionary revenue for the museum.

Recognize and Deal with Ten Big Retail Sins

I'm often asked, "If I can focus on only one aspect of my store to make it more profitable what should it be?" This is a difficult yet understandable question, since most managers, buyers and salespersons already have too much to do.

The following is a list of "sins" that one in ten store managers recognize, but not one in a hundred does anything about.

Not using a merchandise buying plan (Open-to-Buy)
The biggest reason museum stores lose money is because inventory levels are not managed properly. In about 1% of the cases the inventory is too low, not giving the store a lush, full, rich, warm and inviting feeling. But in 99% of the cases inventory is too big, requiring frequent markdowns and resulting in eroded margins and profits.

If you do not consistently use a merchandise buying plan stop reading this chapter now, start using a plan today and save the remainder of the ideas in this chapter until some time in the future!

Except for this sin, the remaining points are not in any particular order.

Not working your customer base
Even in museum stores with strong tourist visitation, a significantly disproportionate percentage of sales come from a relatively small percentage of your customers. Your best future customer is a current customer. It costs five to ten times more to get a new customer than to hold on to a

current customer.

These three statements alone should compel you to do all you can to identify and stay in touch with your best current customers. This doesn't mean you shouldn't be courting new visitors, but new customers should be built on the base of your current customers.

Current customers are important because in some way you have already made a connection with them. Whether they bought a 25¢ pencil or a $5,000 piece of glass, you satisfied a need and have at least started a relationship. You should nurture this relationship by contacting all your customers three to six times a year, especially towards the year-end holidays, and invite your very best customers to product previews and other special events.

Not being known for something – almost anything

You can create the *want* in what visitors want to buy by developing the breadth, depth or unusualness of one to three product categories into something really special. It's one part of the WOW factor. Being known for something will draw people from a wider geographical area and compel them to buy because they may not see such an outstanding selection again.

Not keeping a complete record of results

To go somewhere you need to know where you are. When decisions about the future of any aspect of your store are made without the benefit of factual data the chances for error are greatly increased. If you aren't sure, for example, which

product categories sell the best and have the highest margins, or if you don't know the average transaction or the capture rate (percentage of visitors that make a purchase), then the accuracy of your decision-making process is decreased. Museum store managers take enough risk trying to determine the whims of the buying public, they should not increase that risk by trying to make buying decisions without the benefit of historical data.

Not triggering buying decisions by focusing the visitor's attention

It is the height of arrogance to think every visitor who comes into the store has the interest and time to look at every product. A better approach is to build displays that focus the visitor's attention on select groups of products. Some of the themes for these displays can focus on permanent exhibits, special exhibits, special events, add-on products, and newest, best-selling and seasonal products.

Focusing on procedures and not enough on motivation

This is the yellow sticky test. Look at the bulletin board in your back room or the back of the office door or the area around your cash register. What we are looking at are all the little yellow stickies and signs you have posted in these areas.

What percentage of these signs are procedure-oriented versus those that are motivational? Of course your staff needs to know how to take a check, run through a credit card, handle a return, operate the point-of-sale system, make the bank

deposit, and open and close the store. But if you spend too much time on procedures and too little time on motivation, there won't be a lot of checks, credit cards and bank deposits to worry about.

Look at the memos you write and the little yellow stickies you post to see how much of your time is spent regulating instead of motivating.

Not believing customer service builds loyalty and sales

A few facts:

- 96% of dissatisfied customers do not complain.
- 90% of dissatisfied customers do not come back.

Of the people who did not return to a store:

- 32% didn't for product-related reasons.
- 68% didn't for human performance reasons.

Retailing has become a service business. The customer regularly reports that service (the experience) and the product are of equal value. They are not going to continue to buy from your store, regardless of how wonderful your product selection and museum are, if customer service is lacking.

If you remember nothing else about customer service, remember these two things:

1. Customer service is based on perception. What you actually do is less important than how each individual customer perceives what you are doing for them.

2. People buy people – they don't just buy products.

Not using proactive selling techniques

Retail competition is stiff, and just because you're a museum store doesn't mean you're not in competition with the entire retail community. The competition is stiff not only in terms of the numbers of stores available but also because of the quantity of products available. You must do what you can to get the customer to buy as much as possible **now**, because the chances of a return visit for a particular purchase once a customer has left the museum is somewhere between slim and none.

While there are many important selling skills, the two that directly increase the average sale are suggestive and add-on selling. Suggestive selling is when you focus the customer's attention on a few select items by pointing them out and, whenever possible, putting the product in the customer's hand.

Add-on selling is the recommendation, either by displays or verbal skills, of multiple items that enhance the purchase.

Under-using signage as a selling tool

Effective signage acts as a silent salesperson that is never absent and always accurate and timely. A reasonable amount of signage can enhance the perceived value of a product, help establish value for higher-priced products and focus attention on the products you choose.

Almost equally important, all negative signage should be eliminated from your store. Retail buying is a tactile

experience. Signage that discourages the customer from touching the product reduces sales. I know that often the goal of this kind of signage is to reduce theft and breakage, but an overzealous effort in this area may reduce these expenses – and reduce sales even more.

Treating marketing as an expense not an investment

A typical museum store should spend 3%-5% of net sales on marketing. This includes advertising plus a whole host of other efforts designed to bring the store to the attention of new customers and keep it in the mind of current customers, members, volunteers and staff.

After satisfying yourself that your buying procedures are under control I would review the remaining "sins", prioritize them and set a timetable for moving through the list.

Use Proven Ratios
to Plan your Future Sales

When you're planning to expand your store, how can you best estimate your future sales?

If your store is truly too small for the visitation and volume of business you're doing, not that you just want more space, additional space should generally result in higher sales. I don't think, however, you can project a specific sales increase percentage based on additional space and improved product presentation alone. Just because the size of your store is tripled does not mean that sales will triple or increase by any other specific percentage. The same is true of additional space for product merchandising. The size of the space isn't as important as how it is used. Excluding e-commerce, mail order, wholesale and the effects of a location that draws heavily from non-visitor retail customers, visitation is the most important factor in projecting museum store sales.

Sales can be estimated by two methods that use well-established museum store factors. In the first method you take your current dollars per visitor and assume an increase based on more breadth and depth of product, the additional space to build more compelling displays, and the projected increase in visitors. (Fig. 1) A second cut at the same estimate uses your capture rate and average sale, holding the rates of increase constant. (Fig. 2)

At this point you should do a reality check by comparing your current data and estimates for the future with museums of all kinds in your area and similar museums in other areas. As a result of the reality check you may change assumptions and recalculate, accept one of the outcomes above or settle on

$2.25	Current dollars per visitor
.45	Plus: 20% for additional product depth and breadth
.16	Plus: 7% for improved merchandising and displays
$2.86	Estimate of dollars per visitor based on additional space
90,000	Current number of visitors
18%	Expected increase in visitors
106,200	New estimate of visitors
$303,732	Sales projection based on increases in space and visitors
	(106,200 visitors x $2.86 per visitor)

Figure 1: Estimating sales – method 1

a projection somewhere in-between.

Obviously you need data like that above to budget your merchandise buying, plan staffing levels and order supplies. But equally important is just simply using your additional space in new and improved ways. The following are some key things you can do with the luxury of additional space.

I always try to view a store from the perspective of the customer. Although you are very familiar with the hundreds of products in your store, the customer isn't. The typical museum store customer has just spent an hour or more looking at hundreds of objects in the museum and now we expect them to do it all over again when they enter the store.

One of the great advantages of an adequately sized store is having enough space to build displays that focus the customer's attention on the merchandise you want to make sure they see. Although you want the store to always look lush, full, rich, warm and inviting, additional space may allow you

$11.75	Current average transaction
2.35	Plus: 20% for additional product depth and breadth
.82	7% for improved merchandising and displays
$14.92	Estimate of average transaction based on additional space
18.0%	Current capture rate
	(% of museum visitors making a purchase in the store)
3.6%	Plus: 20% for additional product depth and breadth
1.3%	7% for improved merchandising and displays
22.9%	New estimate of capture rate
106,200	New estimate of visitors
$362,851	Sales projection based on increases in capture rate & average transaction
	(106,200 visitors x 22.9% capture rate x $14.92 average transaction)

Figure 2: Estimating sales – method 2

to spread out your merchandise, define product categories more clearly and give the visitor's weary eyes a little respite by easing the feeling of dense merchandising.

Having enough space may also allow you to expand your merchandise selection into larger, more expensive and higher-margined merchandise such as jewelry or original art.

Perhaps one of the great sales-generating, margin-widening advantages of adequate space is being able to merchandise expensive products in a manner that enhances their perceived value. The customer needs to sense that your most expensive products are something more than just your regular merchandise with a higher price. Expensive products, merchandised cheek-to-jowl with less expensive merchandise, suffers in the comparison. In this kind of

compact merchandise setting the less expensive merchandise lessens the perceived value of the expensive merchandise, but the expensive merchandise does little to improve the perceived value of the less expensive merchandise.

Another advantage of additional space is the ability to test new product categories. You should always be looking for new products to replace tired, low sales, narrow margin lines. By having the space to give new products a prominent position you can quickly gauge their appeal and react more quickly with reorders or, if necessary, the cancellation of unfulfilled orders.

It's also nice to be able to increase your selection of hand-crafted merchandise. This has the advantage of increased margins and generally looks better if it is not densely merchandised. Hand-crafted products are one of the hottest product categories in museum stores. An expanded selection in this area makes your store unique and gives you the retail pricing flexibility to expand your margins.

Book signings, craft demonstrations, readings and other in-store events help to build customer loyalty and retailing excitement. Having the room to stage these events without disrupting the entire layout of the store is a revenue producing luxury.

Finally, you can use your additional space to fill in retail price gaps in your existing product categories. After reviewing the retail pricing of each of your product categories, determine if the bulk of your products are in the price range most appealing to your customers. Is there a smooth flow

of products from one price point to the next so customers can increase their expenditure by comfortable increments? Are there sufficient products in the upper price range of each product category so that at the holidays or for special occasions a customer can find an exceptional item?

I'm sure you can't execute all these ideas, but pick the ones that will work best for your store and turn your additional space into image-enhancing, profit-generating square footage.

Learn How to Project the Inventory You Need to Open a New Store

We're opening a new museum and store. How do I know how much inventory to buy?

Finding and choosing the right product is often easier than determining how much to buy. Both aspects of the process are, however, important to the successful launch of the store. Let's first focus on how much to buy.

One can only hope that the planning for the store resulted in a size that meets your needs based on projected visitation, expected destination shoppers, and product selection. Visitation is the heart of any calculation. Ideally it is the number of people who come in close proximity to the store, when it is open. Museums make this calculation in many different ways but, in general terms, this is the best *retail visitor* count.

Destination shoppers are people whose visit to the institution is driven by the desire to shop at the store. The impetus for these customers may be the unique product selection, convenience, free parking, or member discount.

Finally, the size of individual products affects the size of the store. A botanical garden may have the same number of visitors and destination customers, but because they may sell potting tables, benches and large pots, the store needs more room.

I am starting this discussion about inventory buying for a new store by focusing on the size of the store. Let's say your store is too small for the customer projections. (In my experience, this is a very common occurrence in new store planning, primarily because of space and budget constraints.)

The inventory available for sale , even though it may not all be on the floor and frequent restocking may be necessary, must still be sufficient for the customer projections regardless of the size of the space. Maybe a few less people will buy because the store is too crowded, but what matters most is the expected number of visitors and destination shoppers. On the other hand, if the store is too big and profitability is an important goal, I would prefer to see creative merchandising, such as facing out more books and fluffing the product, used as techniques to make the store look full instead of buying more than the visitation-based projections call for.

So, how much should you buy? What should be your initial Open-to-Buy?

Perhaps using the Museum Store Association's *Museum Retail Industry Report* as a guide, you could start by making a couple of rough revenue calculations for the entire year based on projected visitation and your type of museum. These sample calculations (based on 100,000 projected visitation) could include:

Sales per Visitor Projection
Projected visitation x typical revenue per visitor
(100,000 visitors x $3.50 per visitor = $350,000)

Transaction Based Projection
Projected visitation x typical capture rate x typical average transaction
(100,000 visitors x 20% of visitors making a purchase in the

store x an average transaction of $20.00 = $400,000)
The Capture Rate is the percentage of museum visitors making a purchase in the store.

Next, destination shoppers who may not be included in the visitor projections need to be accounted for. This becomes an educated guess because I have not seen any reliable numbers about this segment of the museum store business. Most museum stores have some destination shoppers but, because they usually can't be distinguished from visitors, with the exception of members asking for their discounts, we really don't know how many. If your store is in a vibrant downtown area with lots of office workers maybe you should add 20% to your visitor-based sales projections for the lunchtime surges. If you're an aviation museum in the middle of nowhere with few destination shoppers the typical visitation-based projections can probably be eased back a bit.

Since we are concerned about initial inventory, you need to buy only a portion of your year-long projected product needs for the opening. This projection includes a couple of subjective factors.

If this was just a typical year and your goal is to turn over your inventory three times a year, you would be looking to have an average of $116,667-$133,333 of inventory (at retail) in stock throughout the year.

Projected sales ÷ desired turnover
($350,000-$400,000 projected sales ÷ 3)
That would be too easy. You have to further adjust this

number for the following three new store initial inventory considerations.

First, it is not unusual for the opening two to six months of a new museum and store to be the busiest period not only for that year, but also for a couple of years or until a blockbuster exhibit is presented. So, instead of having only 25% of your projected yearly sales on hand for the first three months you may want to have 40%.

Second, in addition to expected sales, the beginning inventory must be sufficient to keep the store looking lush, full, rich, warm and inviting as you make the initial sales. In other words, you can't have just enough inventory to meet sales demands because that would result in an empty store after those sales are completed. So, to the projected sales must be added the inventory needed to simply fill the shelves.

A third consideration is a philosophical decision. I recommend to my clients that they go into the opening with as much of the total inventory of the two projections above as possible. I would prefer to have the manager concentrate, for the first couple of months, on the management and operations of the new store and the face-to-face initial interaction with customers, rather than placing orders. Sure, some best sellers may need to be replenished, but I'd rather have the manager/ buyer on the floor instead of on the computer in the back room. Of course, if the unavailability of additional short-term storage or financial constraints does not allow this bulking up before opening, then a buy-as-you-sell program will have to be used.

After determining how much to buy, the next decision is what to buy.

What's most important to consider in this area? First, you want the product to reflect the mission and the exhibits of the museum. With this focus you will generally avoid UBIT problems and make the product selection unique when compared to commercial retail stores. It is the uniqueness of the product selection that is the most compelling attraction for museum store destination shoppers and results in increased average transactions.

Within the mission-related product selection you also want to make sure the products meet the perceived needs of the customer. One way to increase the chances of satisfying the customer is to use the Product Distribution Matrix (Fig.1 and Appendix, Form 2) to guide your buying. Using a separate form for each product category, across the top, horizontal axis, post the range of customer needs that should to be met by the products in each product category. Along the vertical axis, down the left side of the matrix, list each product or group of similar products being considered for inclusion in the initial inventory. By comparing the products listed along the vertical axis to the needs along the top, you increase the chance of opening with a product selection that meets a broad range of customer needs.

There are no simple answers to the initial inventory questions for a new store. Veteran museum store managers and buyers are always willing to help with product selection suggestions, but quantity is more difficult. The bottom line

is that you must strike a subjective balance between the visitation hopes of the museum's administration, the strength of opening events, the exhibit schedule and your gut feeling about reasonable expectations.

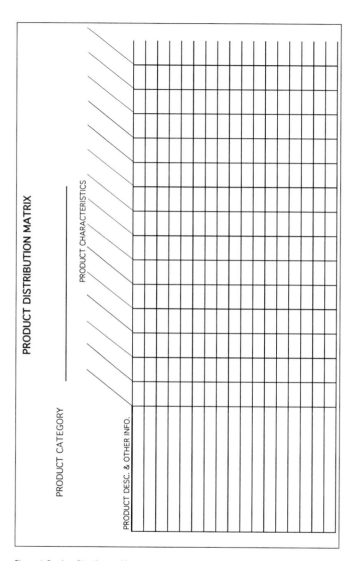

Figure 1: Product Distribution Matrix

Use Competition To Enhance Your Product Range

Is a new and competing commercial store opening up in your area? In general, the threat to your sales can come on four fronts.

First, you must recognize the new store has one advantage over you. They will not be restricted in the breadth of their product selection to merchandise related to any specific institutional mission as you are restricted under Unrelated Business Income Tax (UBIT) provisions. They will be able to carry products that are art, science, history, child, horticultural, etc., oriented and in whatever quantity they can afford.

What an opportunity for you! This competition will help you carve out product areas related to your museum and offer a depth of product selection that they will not be able to match. You can take their breadth of product selection and turn it to your advantage by contrasting it with the depth of products within your mission-related areas. As you become known for your product selection you will draw customers from a wide geographical area and heighten the WOW factor. Customers will stand in front of your selection of products and think, "Wow, I have never seen so many different shapes (colors, sizes, designs, titles)." Often, especially tourists, will feel compelled to buy because they aren't sure they will ever see such a selection any place else.

One point of special emphasis. It is important to keep your product selection relevant to your museum's mission and exhibits to avoid challenges from commercial stores who have been known to lodge complaints when museum

stores are stocking products not related to the mission of the museum.

The second counterattack can come in the area of product knowledge. While the commercial store will employ nice enough salespeople, for them it is only a job. If you are doing your job right, however, your employees and/or volunteers will have a depth of product knowledge unmatched by the commercial store personnel. In addition it is also hoped that your sales personnel will be dedicated to (or at least supportive of) the museum, enthusiastic about the product selection and will project to your customers how important store revenue is to the financial health of the museum.

The financial support the store provides the museum is the heart of the third arrow in your quiver. Tell the customer where the money goes. It is important to inform the customer that the revenue generated in the store goes to maintain the museum and support its continuing education, community outreach and exhibit programs. The customer needs to understand that the money doesn't go into some dark hole known as the county budget, or to support highway construction projects someplace in your state. In a not-so-subtle manner you want to contrast that the money generated by your store stays in the community and is not sucked into a multinational conglomerate.

The goal of the fourth thrust is to blow the socks off the competition in the area of customer service. You need to match their services, service for service and then add a few goodies. Shipping, gift wrapping, delivery to local hotels,

layaway programs, gift certificates, children's play area, special orders including access to *Books in Print®*, gift baskets, communication skills, return policy and perceived value are all customer service components through which you can distinguish your store from the competition.

There are two final advantages for the museum store. In most situations, since your customers have been drawn to your location because of the museum, you have customers that are motivated to go into the store for reasons beyond just making it another stop on a buying trip. If the components of your store give it an inviting retail atmosphere you can capitalize on your motivated customer. Also, remember, in most cases price issues are not a disadvantage for museum stores when compared to commercial stores or the Internet.

Balancing Buying
Inventory vs Consignment

The two big advantages of including consignment products in museum stores are the reduced need to finance inventory and the opportunity to test new, especially higher-priced products and works from new artists, with greatly reduced financial risk.

In a consignment arrangement the store procures products – often but not always original works of art – from an artist or wholesaler on a delayed payment basis. When the products are delivered to the store, physical possession transfers but the products still belong to the artist and the store does not have to pay for them. It is customary to have the unsold product insured under the store's general insurance policy. When the product is sold the ownership of the goods is transferred to the customer, the customer pays the store and the store pays the artist. At no time does the store have ownership of the consigned product.

Using this description of consignment, let's look at consignment details and the similarity and differences between consignment and buying for resale.

Ownership: Under a consignment arrangement the store never owns the product. When buying for resale, the store is the owner of the product upon delivery regardless of when payment is made.

Merchandising Space: In both scenarios the product takes up space and, as discussed later, this factor becomes a major consideration in determining the amount of consignment to carry.

Inventory Investment: Although similar to dating programs

where the product does not have to be paid for until or after the product will probably be sold, consignment products never have to be paid for until the product is sold.

Recording of Income and Expenses: The percentage of the sale retained by the store is recorded as income when the product is sold.

Inventory: Although actual practice varies, you typically do not include product you have on consignment in an inventory calculation. Most stores, however, regularly check their inventory of consigned product against consignment records and always count the product when other storewide inventories are taken.

Some stores want to include consigned goods in inventory in order to keep track of the quantities on hand for each item in the store and calculate total inventory available for sale by department. Although point-of-sale (POS) systems handle this in many different ways, a common thread is to assign a retail price and cost of goods (the amount expected to be paid to the artist) to these products and put them into a Consigned Goods category that can be easily identified and extracted when necessary to analyze financial statements.

From the museum store's financial records standpoint:

- When a product is received from the artist or wholesaler there is no entry.
- The consignor usually pays freight in, or it is hand-delivered, so this typically requires no entry.
- When a sale is made the revenue is recorded and the payment to the consignor becomes a cost of goods sold.

Setting the Retail Price: There is some concern that the artist too heavily influences the retail price of consigned merchandise. If you follow the basic rule of establishing the retail price for a product in your mind (in other words, what do you think you can sell it for?) before establishing the consignment arrangement, you can lessen this problem. If you feel you can retail an item for $1,000, and you are willing to give up 50% to the artist, then you can be clear with the artist that they cannot expect more than a 50/50 split when the item sells. In general, if you (not the artist) first establish the appropriate retail price for a specific product, and then negotiate the consignment contract, you can maintain control of pricing and margins.

When negotiating the consignment agreement make certain you retain the right to establish retail prices product by product or by groups of very similar products. You can also establish a range for the retail price within which you can change the price without consulting with the artist. This will allow you, for example, to offer a discount to museum members or put the item on sale without having to contact the artist.

Income Statement: I strongly recommend taking the time to breakdown the revenue and cost of goods sections of an income statement into the same product departments/ categories. One of the categories in each section can be Consigned Goods. By doing so, the impact of consignment goods and each product department becomes clear within the totals for each of these sections of the statement.

With this information broken-out, calculations such as cost of goods percentage, inventory turns, stock to sales, dollars per square foot and other ratios can be made for consignment and individual departments and then amalgamated for the retail presence as a whole.

Open-to-Buy (OTB): Consignment does affect Open-to-Buy. Consigned product takes up space, so you need to determine how much space you want to give it, and then deduct that space from the space available for purchased products for which you calculate an Open-to-Buy.

You may also have an overall cost of goods percentage goal in mind that will be affected by how much consignment product is sold. Although payment to consignors varies widely, it typically is more from a percentage standpoint than the cost of goods of products for resale. For example, if your goal is to have an overall cost of goods of less than 50%, and you typically pay 60% to consignors, then you must find other product categories with lower costs of goods to counterbalance the consignment product, or reduce the quantity of consigned product or the percentage paid to the artist.

Another factor affecting Open-to-Buy may be the availability of cash with which to make purchases. If budgetary restraints limit what you can purchase for resale, consignment with its no-cash-up-front characteristic, can become a more attractive alternative, even if the final cost of goods may be higher.

Similar to the income statement, calculate separate Open-to-Buys for each product department including consigned goods and then amalgamate them into one, all-encompassing

document. As with other departments, consignment will be affected by revenue and expense goals, the availability of space and all the other factors that affect your buying decisions.

If you are going to carry consignment here is a checklist of things to consider:

- Have a written and signed agreement.
- All the terms of the consignment agreement are negotiable. Your desire to sell the product is balanced by the artist's need for the exposure you can offer. Artists would like to brag that their work is sold in the XYZ Museum Store. Terms to be negotiated include revenue split, pricing flexibility and length of time the product will be merchandised before being returned to the artist if unsold. During negotiations do not give up your right to determine how the product will be merchandised.
- Consignment product is not included in the calculation of an Open-to-Buy because you will not be paying for the product up front. Consignment product, however, does take space in the store and depending upon how much you carry, can impact how much other product you will need in inventory. If consignment is a significant percentage of your product mix you may want to calculate an Open-to-Buy based on expected costs when the pieces are sold to make sure you have the proper level of inventory to generate the revenue you are projecting from your consignment merchandise.

- Make certain your insurance covers consignment pieces (not just inventory purchased for resale) and that the artist understands the risk inherent in leaving the work in your store.

- Make sure the artist of the product is paid promptly after the sale.

- Prepare a record system, usually by source, that tracks descriptions, inventory numbers, number of items, retail price, revenue split, date accepted, date sold, date returned unsold and a column for the artist to acknowledge delivery or removal of items.

- A Customer Return Policy for your consignment sales must be established both for the customer and artist. The customer must be advised in writing that regardless of what the return policy is for other products there is, for example, a 30-day limit for returns of consignment merchandise. The artist must also agree that they will not be paid until the return period has expired.

- An Artist Return Policy: It is reasonable to set a minimum length of time that a product will be in your store. After this period the contract can be renewed or the artist has the right to remove the item from your inventory and you have the right to return it to the artist. It is reasonable to assure the artist that the product will be on display during the length of the contract and it is equally reasonable for you to retain the right to determine how the product will be merchandised.

Consignment sales can be used to your profit advantage and enhance your product selection, so don't dismiss them because of the need for contracts and additional paperwork.

CUSTOMER SERVICE AND SELLING

Building Customer Relationships

The first step toward evaluating and elevating your relationship with your customers is to establish expectations. What level of interaction do you want with your customers in the store and through telecommunications? What are you doing now? How do you want to meet your goals? Will what you do differentiate yourself from other retail experiences? This chapter is not about the quality of the interactions – the assumption is they will be the best you can do – but about what you could do.

First, a general comment about customer relations. Building relationships with your customers is now both easier and harder than it used to be. It's easier because there are so many tools, especially in the area of social networking. It's harder because these same tools are easily available to all stores at minimal cost, and customers have greater demands on their own lives, which makes creating an impression more difficult.

In store

Let's start with the most basic concept – listening. Truly listening to comments, complaints and requests can immediately lead to an improved relationship with your customers. Just the act of listening is powerful, but if it leads to action that is recognized by the customer the potential positive impact is enormous. For example, respond to requests for products even if you can't place a special order or add the product to your inventory. React too, to comments, suggestions and complaints with professionalism, courtesy and appreciation, and in such a way the customer believes

their communication was heard.

One way to be proactive about customer relations is to conduct exit surveys. Periodically during busy days, station someone who is relatively well-dressed, identified with a nametag and knowledgeable about the museum and product selection, at the store exit. Their task is to ask customers leaving the store an open-ended question such as, "How was your shopping experience in the store?" and then listen to and record the responses. It's critical to the *Did they hear me?* relationship-building process, and the potential impact on store improvement, to document the responses and make the noting of the answers obvious. Just listening is not enough, the customer needs to know their comments have been understood. By the way, don't forget to regularly ask your paid and volunteer staff for their input too.

Museum stores are the best source of continuing education about the mission and exhibits of a museum. At the core, museums are educational institutions and that experience should not end with exhibit signage and docent tours. Having product knowledge and being able to answer questions and recommend appropriate products that satisfy visitor interests and needs is also a subtle yet powerful relationship-building tool.

Telecommunications

Telecommunications includes the telephone, email, e-commerce, social networking tools, online reviews and snail mail.

How are we doing? You see variations on this question from the back of trucks to electronic follow-up inquiries. Too often, however, customer relations is based on inquiring about what seems to be working and neglecting getting feedback from customers about what they would like.

Freestyle, open-ended *What can we do for you?*, and *What can we do better?* feedback can be secured through:

- A toll-free number at the bottom of receipts.
- Handing out comment cards with an incentive to return them.
- An invitation to comment at the end of an ecommerce transaction.
- Short requests for comment emailed/mailed to customers.

The formatting used to request responses is important. When asking for feedback make the request sound like something that will benefit the customer rather than an assignment that will only benefit the store. A request to evaluate established activity (probably areas about which you already have some doubts) typically includes a numerical, letter or star scale of responses to specific questions and a space for freestyle comments.

Getting freestyle feedback is a little more difficult because you want the respondent to go wherever they feel they want to comment. In this case, the request may have a reverse structure with more encouragement to respond in an open-ended manner. Perhaps the ultimate level of feedback is to

encourage customers to use the telecommunications method of their choice to provide a full description of anything of concern, which you should address quickly and directly. With luck these responses – and monitoring Twitter, Facebook and other social networking channels – will make you aware of areas of customer concern that may be festering below your radar.

Product-specific freestyle reviews should also be encouraged. Don't be too afraid of negative reviews because they are actionable and there are some studies that show negative reviews actually encourage sales because they add to the perception that your products are presented in a balanced manner. Done right, these reviews may reduce the need for a potential customer to leave your site, with the possibility of not returning, to secure comparative information.

Is Your Store Somewhere Customers Want to Be?

When you're planning to upgrade your store, what are the most important aspects you should tackle? Let's start by asking questions that will help evaluate your current store and determine how to spend available funds.

Who are your customers? This is the first and most important question you need to answer. Obviously, this does not mean knowing all your customers by name, but rather having a clear understanding of their characteristics so the merchandising of products meets their needs.

What do your customers buy? The second question to which you should have a definitive answer before doing any planning will help to rank the relative importance of the product categories to your customers based on past performance. You may want to evaluate both revenue generated and units sold.

What's the relative value of your product categories? The answers to this question will help you allocate a finite amount of space so that each product category generates as much revenue and profit as possible for the merchandising space used. It's important to note here, since books are at the core of the educational mission, they are frequently not held to the same comparative standards as other product categories.

For each product category, rank the following measurements compared to the other product categories in the store, not in comparison to other stores or industry standards:

- Revenue generated.
- Profit margin.
- Turnover.
- Space used for merchandising.

The goal for this comparison is to determine whether the product categories that best support the store are being given sufficient space and if the space devoted to less important categories is held in check.

The next three evaluations are more subjective in nature.

Does the ambiance of your store encourage customers to linger? The more time a customer spends in the store, even if customer service is not what you wish it would be, the better chance there is that they will find something they want to buy. Simply stated, if you put yourself in the shoes of your customer is your store a place where they would like to spend time?

Does the layout and design of your store help to increase incremental sales? Perhaps the most critical, and in some ways the easiest, way to increase revenue is to encourage people to buy more – NOW! This is especially important for museum stores because so many visitors are infrequent or one-time customers. The best way to do this is through great customer service, proactive selling and the creation of display areas.

Merchandising is where product is placed in the store and from which the customer can make their selections. Displays are where you build a vignette which incorporates several products with a common theme, tells a story and visually suggests add-on purchases. Does your store include areas where you can build a display or is every square inch merchandised?

Do the fixtures enhance the overall image of the store? Every aspect of fixturing should support the pricing and value of the products in the store. If you have a more sophisticated

institution and higher-priced product selection, the fixtures must help to create an ambiance that reflects positively on your product selection. Stores selling lower-priced, less sophisticated products can have simpler fixturing, but they still have to be clean and in good condition. Regardless of the type of store, if glass shelving is chipped, laminate is peeling or the carpet is irreversibly dirty, correcting these deficiencies would be a good place to start spending money.

Finally, overall, the greatest gift you can give your store is flexibility. Sure, jewelry and posters, for example, need dedicated fixtures, but most of the remainder of the store will benefit from casters under freestanding fixtures so the store can be rearranged more easily; adjustable shelves so taller and shorter products can be accommodated; and a vertical merchandising system that helps to make efficient use of all the space above each square foot of merchandisable space.

All the comments above are focused on revenue generation. You must fully recognize, however, that in the museum store business some product selection and merchandising decisions are made with only the mission of the institution in mind.

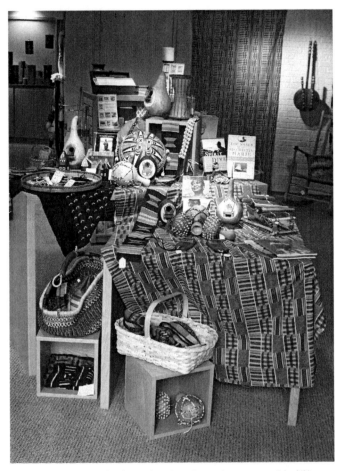

Display of products on the first fixture, featuring a theme relevant to a special exhibit. Historic Arkansas Museum, Little Rock, Arkansas.

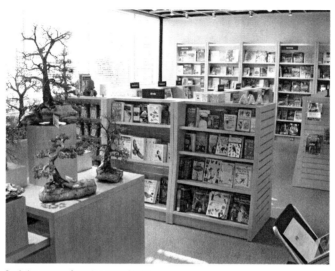

Book department featuring natural light.
Morton Arboretum, Lisle, Illinois.

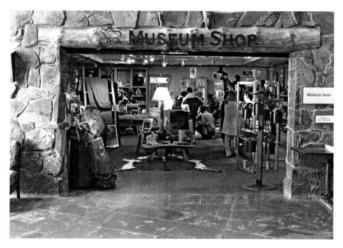

Dramatic and warm entrance to the store.
National Museum of Wildlife Art, Jackson, Wyoming.

Learn Handselling Skills
and Sell More Books

What is handselling? Handselling is a customer service not just a selling tool. No museum store customer can be expected to look through all the books you have in stock – regardless of how big or small your book selection is or how much time the customer has. The goal of handselling is to help the customer find a book that fills a need. The need may be for their personal education or interest or to give as a gift.

Now let's deal with two common misconceptions about handselling. First, most typically in a museum store, handselling is not pushing a book but rather suggestive selling of a title in a subject area the customer has indicated to be of interest. Second, handselling isn't only done verbally.

What are some handselling skills and tools? The most common handselling skill is answering a customer question or engaging a customer in conversation that ends with the recommendation of a title, and hopefully the sale of a book. That doesn't mean everyone in the store needs to know every book in depth, but it does mean if a customer asks about a topic the sales staff is able to recommend a book and provide the reasons for the recommendation. Often a staff person with exceptional knowledge of the book selection or a curator or museum director may predetermine this recommendation.

It is perfectly fine to predetermine that a specific book will be recommended when the conversation centers on a certain topic. It's also fine to recommend a book for which you have great enthusiasm as long as you make it clear why it is your personal favorite.

A common pitfall of conversational handselling is doing

too much talking and not enough listening to the needs and desires of the customer.

Shelf-talkers (signs), much like recommendations in a wine shop, are a non-verbal form of handselling. Highlighting a book for its readability, organization, quality of maps or illustrations is a way of making suggestive sales. The shelf-talkers can be originated by store personnel or – even more effective – be recommendations by a third party, including other museum personnel or authorities on the subject not associated with the museum.

To heighten the effectiveness of handselling, you may want to consider scheduling your most knowledgeable book salesperson for when you're busiest or in coordination with museum events that appeal to a book-reading segment of your visitation.

Handselling can also be done through:

- Displays
- Newsletters
- Bestseller lists
- Mailings
- Email blasts
- Reading groups
- Casual discussions
- Planned discussions
- Staff, curator and director favorites
- Author events
- "If you like..." recommendations such as, "If you like tales set in the Southwest or author Tony Hillerman you may also want to read..."

My broad definition of handselling is when the salesperson recommends, or other materials suggest, book titles that may meet the needs of the customer.

Involve and Train Your Volunteers

Let me begin by clearly stating that I believe using volunteers in museum stores can be a tremendous revenue-generating, money-saving customer service asset. The key factors that lead to achieving these goals include clear establishment of roles, thorough vetting, proper training, consistent supervision and support, and high and specific expectations. For any store volunteer program to work, management must believe the right volunteer, trained and managed properly, can do just about anything as well as a paid staff person.

Establishing roles and vetting

The required level of vetting is primarily determined by whether the volunteer will only have customer service duties or if they will also be expected to use the point-of-sale system and handle payments.

If the volunteers will only have a customer service, ambassador role, the most important vetting issues become those closely associated with smiling, energy, pleasant demeanor, willingness to learn about the products and other factors that generally fall under the heading of warm and fuzzy. In a previous retail life I hired an older woman who knew everything about the children's books we sold but was deathly afraid of our rudimentary point-of-sale system. Since we always had at least two people on the floor she worked with the children and their parents to select books and then would walk them and their purchases over to the cash-wrap, thank them and graciously tell them that her colleague would now complete their purchase. In this scenario the customer got

product knowledge, great customer service and a quick and efficient checkout.

As part of the vetting process, find out what the potential volunteer likes to do and what they would prefer not to do. For example, if they are not thrilled about interacting with customers but love putting their bookkeeping background to work, perhaps receiving products and matching paperwork is a good way to use those skills.

Training

In addition to specific training for the roles and responsibilities assigned to the volunteer, general guidelines for the customer service and selling process (for the entire store team) should be established. This includes three segments: rules, expectations and consequences.

Rules: These are things that must be done in a specific manner. Whatever the rules, it should be made clear that they must be followed exactly as established until they are officially changed. That doesn't mean they can't or won't be changed and suggestions for change are not welcome, but until they are officially changed the rules are the rules. The rules, for example, can include:

- Not congregating behind the cash-wrap.
- Specific procedures dealing with cash handling and opening and closing the store.
- Making eye contact with customers.
- Offering an appropriate greeting.
- Learning to operate the point-of-sale system smoothly.

- Treating everyone equally.
- And such things as stopping conversations and other activities when the customer enters the store.

I do not encourage stores to establish rules related to exactly what to say and when, based on such criteria as length of time in the store or how far into the store the customer has moved.

One frequently-repeated complaint about volunteers is management's inability to rely on their attendance. While improving reliability is a complex issue that includes understanding the importance of the store to the museum and team spirit, there is one rule that can help with consistent personnel coverage. Simply described, a roster of store volunteers is distributed to all volunteers. If a volunteer will not be able to fill their shift they are required to contact a minimum number of other volunteers to try to find a substitute before contacting store management. When established properly this helps to assure desired floor coverage, reduces management's need to deal with scheduling issues and builds team cooperation through the gentle (and sometimes not so gentle) pressure of the pool of volunteers on those who do not regularly fulfil their responsibilities or do not volunteer to substitute for others.

Expectations: Expectations are those things volunteers are expected to do including some softer rules and chores during slow times. These may include:

- The requirement to approach customers.

- Highlighting specific products.
- Cleaning, straitening, remerchandising.
- Listening to customers.
- Keeping up with product knowledge including what's new in the store and how the product relates to the mission of the museum.
- Devoting full attention to customers when they are in the store.
- And generally anything that is covered by the *if you can lean you can clean* adage, (i.e. find something to do).

Two other aspects of expectations are leading by example and managing the expectations. Remember, to make any of this work you need consistently to inspect what you expect. If you want volunteers to sell, give them some guidelines. Instead of simply letting them loose in the store, provide some selling guidance that limits their choices of how to proceed, concentrates their efforts on techniques that provide the best results for the effort and allows them to interject some of their personality into the process. Some selling parameters include:

- Making sure customers are greeted and acknowledged in a uniformly warm and enthusiastic manner.
- Suggesting opening lines that evoke a positive response from the customer and provide some idea about what the customer's goals are while in the store.
- Expecting some add-on/suggestive selling that helps the customer meet their goals, introduces key products and increases revenue.

To help support the rules and expectations, make sure volunteers understand:

- When a customer encounters a volunteer, the volunteer is the store.
- *People Buy People*, they don't just buy product.
- The customer is (almost) always right.

While rules and expectations are important, you want the personality, personal knowledge and experience of the salespersons to come through to the customer.

Consequences: The store is different than many other parts of the museum where volunteers work. The store handles money and the near-equivalent of money in the form of products, often has more interaction with visitors than any other museum department and is frequently part of the visitor's last impression of the museum. For these and other reasons, store management has the responsibility to advise volunteers in advance about the possible consequences if expectations are not met, including reassigning them to other places in the museum.

Support

Like any store personnel, volunteers need to be supported. They need refresher courses on the use of the POS, assistance to stay up-to-date with new products, reminders about the rules and expectations and plenty of sincere appreciation, expressed verbally at least every day.

Connect Well with Your Foreign Language Customers

It can be safely said that most customers, regardless of country of origin or cultural differences, will appreciate very similar interaction and assistance from your store staff. Let's start with some basic human needs around which you can build your foreign visitor customer service policies.

Everyone wants to feel welcome. A smile, nod of the head, or a nearly universally understood *Welcome* or *Hello* is all that's needed. Placing small signs around the store welcoming the most frequent foreign visitors in their language can enhance the welcoming spirit. Using their native flags as background graphics for this signage will let the visitor quickly identify with the message.

Everyone needs to feel important. Every question and every purchase, regardless of size, is important to the visitor and should be treated as such by the store staff. Just as we treat a 25 cent purchase by a grade school student as important, we should treat the most basic question and postcard purchase by a foreign visitor as equally important.

Foreign language customers are concerned about the result of not being understood. Most misunderstandings that occur in a store setting are less stressful than missing transportation connections, but they are disturbing none the less.

There are some very specific things that can be done to enhance understanding.

A number of institutions have reported developing a cross-referenced notebook that contains common retail-related phrases in English and a variety of other languages. The store

staff person can point to a phrase in English that can then be read by the foreign visitor in their language. The system works just as well in reverse, with the foreign visitor finding a phrase in their language that is translated into English. Using graphics and adding pronunciation aids to the list is also helpful because, as with most people, if you make a good try at pronunciation the foreign visitor appreciates it. If you have a computer in the store with an internet connection you can log on to a translation site for additional help.

Since store staff often get involved in conversations not at all related to retailing, having a series of English-to-foreign language and reverse dictionaries behind the counter is also helpful.

Maintaining a list of staff members who speak a foreign language augments these activities and is a better reaction to more serious questions or emergencies. This list can be kept by the institution's operator or on the intranet. Remember that basic familiarity with a foreign language is all it takes to make great strides in understanding.

Colleen McLaughlin from the Salt Lake City Public Library advises that the library seeks out volunteers from different cultures and with foreign language skills. During the Olympics, they designed banners that said *Welcome* in about 30 different languages. These banners were hung at the entrance to each of their libraries. They also purchased additional foreign language newspapers so visitors could stop in and read the local news from their country in their native language. Over the years the library has met with leaders from

numerous cultural groups and asked their advice on making people from their culture feel more welcome in the library.

When communicating verbally here are some tips to improve understanding:

- Speak slowly and distinctly. Speaking loudly isn't very helpful!
- Use simple syntax and vocabulary. Avoid using euphemisms (All hat no cattle); idioms (Costs an arm and a leg); slang (White elephant); acronyms (SKU/PLU); or jargon (Our POS is having trouble reading the ISBN).
- Be careful with numbers – write them down if there is any question or confusion.
- When a transaction is completed a simple *thank you*, *efaristo*, *danke*, *gracias* goes a long way toward showing respect and satisfying the need to be appreciated.

Attention to cultural differences probably affects the visitor's desire to feel comfortable more than anything else we can do. That doesn't mean you have to deliver change to a Japanese customer on a tray as they do in Japan, but there are things you can be aware of and do for your most frequent foreign customers. Some hints on how things are done in foreign countries are available on www.executiveplanet.com.

Beyond the specifics above, training your staff in some simple protocols will also help to set the right tone. Encourage your staff not to whisper, giggle or engage in similar activity when a foreign visitor (or anyone for that matter) is in the

store, because it's just natural for the visitor in this situation to think that they are the focus of this activity.

Also make sure slang terms for different nationalities are not used. This is especially important because many of these terms have pejorative connotations. Never assume that people don't understand English.

In addition to the tools above and the application of common sense, an obvious attitude of willingness to connect goes a long way to bridging difficulties.

FINANCE

Understanding and Using
Your Income Statement

What common ground should you be looking for if you're having difficulty coming to a meeting of minds with your accounting department about reports that reflect the financial activity of your store?

First a disclaimer. I am not an accountant and this is not intended to be an accounting chapter, but rather a discussion of one aspect of the practical accounting needs of a museum store. The following comments are focused on the income statement or P&L. Other important reports such as cashflow, balance sheet, ratio calculations, and Open-to-Buy are not addressed.

The income statement is an important document because it is easily prepared and provides a snapshot of the condition of the store. This snapshot can be focused on one month (generally the shortest period) or a cumulative year-to-date period representing several months or a year (generally the longest period). Suggestions for a range of comparative income statements are included later in the chapter.

There are two main reasons why most accounting departments have difficulty preparing a retail income statement. First, the typical retail income statement is different from the income statement prepared for other departments. The typical income statement includes two sections: income and expenses. The retail income statement also includes an income section, but extracts Cost of Goods Sold and Freight In from the expense section and creates a separate section just for these two expenses. So the retail income statement has three sections: income, cost of goods

sold, and other expenses.

The second difficulty accounting departments have with a retail presence stems from the fact that most institutional accounting software cannot accommodate the three-section income statement. As a result, preparing a retail income statement requires either additional software or hand preparation of the reports. We can proceed under the assumption your accounting department's software can either accommodate the three-part income statement format, or they are willing to prepare the reports manually, but my experience has showed that it's better to get information from the accounting department in a format with which they are comfortable and then prepare a retail income statement yourself. The following are some guidelines for the kind of formatting you may find useful.

Fig. 1 shows a typical museum store income statement.

Heading: The heading for the report should include the current month, the number of months included in the report if it includes cumulative information, and the fiscal year.

Income: The income section starts with the revenue generated from the sale of merchandise, to which adjustments are made to reach net sales. These adjustments can include additions for retail-related income sources other than the sale of merchandise, subtractions that refine the income from the sale of merchandise, and elimination of income for which the store is only a transfer agent, such as sales tax. The income section can be further expanded to report income generated by merchandise departments rather than combining all

SAMPLE PROFIT & LOSS STATEMENT

For the ___ month period ending _____
Fiscal year ending: _____

	Month		Year to Date	
	$	%**	$	%**
INCOME*				
Gross Sales		%		%
Plus: Wrapping / Shipping / Misc. Fees		%		%
Less: Discounts		%		%
Sales Taxes		%		%
NET SALES		100.00%		100.00%
COST OF GOODS*				
Cost of Goods		%		%
Plus: Freight In		%		%
TOTAL COST OF GOODS		%		%
GROSS PROFIT		%		%
OPERATING and OTHER EXPENSES				
Payroll		%		%
Payroll - Benefits		%		%
Payroll - Taxes		%		%
Volunteer Related Expenses		%		%
Rent		%		%
Office Supplies		%		%
Supplies - Packaging		%		%
Supplies - Pricing / Displays		%		%
Freight Out (Suppliers)		%		%
Freight Out (Customers)		%		%
Travel		%		%
Postage		%		%
Repairs & Maintenance		%		%
Professional Services		%		%
Telephone		%		%
Charge Card Fees		%		%
Bad Checks / Bank Charges		%		%
Utilities		%		%
Security		%		%
Marketing		%		%
Damage / Theft		%		%
Indirect Expense Allocation		%		%
Miscellaneous		%		%
TOTAL OPERATING and OTHER EXPENSES		%		%
NET INCOME / LOSS		%		%

* INCOME and COST of GOODS can be recorded by product category for more detail
** Percentages for all line items based on Net Sales

Figure 1: Typical Museum Store Profit and Loss Statement

sources together. This refinement generates very helpful, more detailed information.

Cost of Goods: The cost of goods sold is what was paid for merchandise received and should include the cost of freight in. The cost of goods section can also be further expanded to

report cost of goods sold by merchandise departments rather than combining all expenditures together – matching the refinement mentioned for the income section. There is often confusion regarding cost of goods and cost of goods sold.

From a practical standpoint, cost of goods is cash accounting that reflects payments made (checks written) for merchandise during a specific time period. The merchandise paid for during a period may or may not have been received or sold during the same period. Cost of goods is just based on when the check was written. For example: merchandise might have been received during month one, sold during month two, and not paid for until month three. In this case, the cost of goods would be reflected in month three only.

Cost of goods sold accounts for the cost of merchandise in the same month as the merchandise is sold. This can generally be accomplished in two ways. First, point-of-sale systems can account for the cost of merchandise as it is sold regardless of when the invoices are paid. With these systems there can be a perpetual calculation of cost of goods sold.

The second method of determining cost of goods sold, generally occurs at the end of a fiscal year. After a year-end inventory has been taken, the cost of goods sold for the year can be calculated as part of the accountant's final report.

From my perspective, unless you have the hardware and software to calculate cost of goods sold on a perpetual basis, it is not worth taking the time to calculate it until the accountants do it at the end of the year. Not calculating cost of goods sold throughout the year does lead to some short-term

distortions, but these distortions become less significant as more months are included in the year-to-date calculations. This is one of the major reasons the year-end statement is so valuable, but it doesn't mitigate the need and importance of monthly statements, even if they only reflect cost of goods.

Operating and Other Expenses: This section should include all expenses other than those for merchandise and freight in. The expenses in the example can be adjusted to meet your needs. Stores with no volunteers can eliminate volunteer-related expenses while smaller stores that are run entirely by volunteers can eliminate payroll-related expenses. Most stores do not pay rent but some are charged a nominal amount. The same applies for utilities. The utility costs for most stores are absorbed by the museum but some stores are responsible for some or all utilities. Simply, add, eliminate or adjust the expense category lines to meet your needs and situation.

One last, but very important, factor. As you see on the sample income statement there is a column for percentages. Every statement income and expense line should be compared to net income. This facilitates making comparisons to other institutions, regardless of size, using percentages rather than raw data.

The Formulas that
Document Store Performance

All experienced museum store managers already know the importance of comparing store results to visitation. This is especially critical during an economic downturn where in many instances store revenue may be down but not as much as visitation, illustrating that the store is doing relatively well. Some of these key measurements are:

· Revenue per Visitor.
· Average Transaction.
· Number of Items per Transaction.
· Capture Rate.

This chapter, however, is about basic, more typical retail formulas that give deeper insight into the financial condition and performance of the store. Remember, retail is detail and a combination of art and science. The art primarily has to do with product selection, merchandising and displays. However, much of the important detail is derived from the science of financial numbers so important to successful retailing.

Explanations and formulas for the following financial factors and ratios are included in this chapter:

· Net Sales.
· Cost of Goods.
· Average Inventory.
· Gross Margin.
· Inventory Turnover.
· Costs as a Percentage of Net Sales.

Net sales

Gross Sales

+ Additional revenue attributable to the store

- Deductions for discounts, returns, sales tax, etc.

= Net Sales

Different museums will start with different Gross Sales and add and subtract different items to get Net Sales. Net Sales is the number against which all expense (and income) numbers are compared. It is the divisor for every line item in a Profit and Loss Statement. This is like using visitation as the divisor to facilitate fair comparisons among periods of time with different levels of visitation or institutions of different sizes. Using Net Sales as the divisor for all line items allows income and expense categories to be compared among museums with less concern about the size of the retail operation.

Average inventory at cost

A key reason to calculate Average Inventory at Cost is to be able to use this number in the very important calculation of Inventory Turnover.

Yearly Average Inventory Calculation #1:

$$\frac{\text{Beginning of Year Inventory + End of Year Inventory}}{2}$$

Although a popular method of calculation, Average Inventory – using only two numbers for the year – can be misleading,

especially if the goal is to drive down stock levels just before inventory is taken, or if inventory is taken at a time of the year when inventory levels are unusually high or low. It is also not unusual to take a mid-year inventory, add that to the beginning and year-end numbers and divide by 3.

Preferred Yearly Average Inventory Calculation:

$$\frac{\text{End of Month Inventory for each of twelve months}}{12}$$

By including month-end inventory numbers from throughout the year, the final number more accurately represents Average Inventory. It's also possible to use the year-end inventory from the previous year plus the twelve inventory numbers from the current year and divide by 13. Please note, while taking a physical inventory for one or two of the numbers is reasonable, if you are going to use more than two month-end inventories the assumption is that you will take numbers from a point-of-sale system month-end report not additional physical counts.

Inventory turnover

$$\frac{\text{Cost of Goods Sold}}{\text{Average Inventory @ Cost}}$$

Visually, Inventory Turnover is seen as product coming in, being sold and ordered again, sold again and reordered, etc. However, the real importance of Inventory Turnover is as a

measurement of the efficient use of inventory dollars. The higher the Inventory Turnover rate, to a limit, the more efficient the use of inventory dollars and the fewer dollars that need to be invested in inventory at any one time.

For example, if your Cost of Goods Sold is $100,000 and your average inventory is $50,000, your Inventory Turnover is 2.0 ($100,000/$50,000=2.0). If the average inventory is only $33,333, the turnover would be 3.0 ($100,000/$33,333=3.0), requiring an average of $16,667 less in inventory.

There are two things to remember. First, because some categories will turnover at a significantly different rate than others, Inventory Turnover is best measured by product category to get a more detailed understanding. Second, too high a turnover rate will have a diminished positive effect because it generates excessive work in the form of ordering, receiving, pricing and merchandising. And, if turnover is too fast, it is more difficult to keep your fastest moving, most popular products in stock.

Cost of goods (sold) percentage

$$\frac{\text{Cost of Goods}}{\text{Net Sales}} \times 100$$

The biggest expense of any museum store is Cost of Goods and it should be the focus of constant attention. In my consulting experience, excess inventory is the most common and negative impact on profitability. Cost of Goods includes the cost of freight in and is commonly expressed as a percentage of Net Sales.

In many ways the discussion of this cost can end by simply stating that the lower the price paid for product the better. However, if getting a lower cost through show specials, free freight or marketing assistance requires ordering too much product, in most cases the impact of having to reduce the retail price to sell the excess product increases the Cost of Goods percentage and negates the advantage of the lower initial cost. Don't misunderstand, take advantage of cost lowering programs but use them prudently and don't exceed your inventory needs.

There is a unique wrinkle to the museum store's cost of goods which is encountered less frequently in commercial retail stores. Catalogues, books and multi-year proprietary product inventory, if not handled properly, can badly distort the Cost of Goods Percentage. It is recommended that excess inventory of these types of products be placed in a virtual warehouse to separate them from the inventory that meets the immediate needs of the store. When the store needs some of these products they are "bought" from the virtual warehouse and only then entered into the store's inventory. Treating these products in this manner will make the contemporary calculation of Cost of Goods more accurate and instructive. Although this product is entered into the store's inventory only when purchased from the virtual warehouse, the virtual warehouse inventory is counted as part of year-end inventory for Internal Revenue Service (IRS), audit and other purposes.

Gross profit/margin

Gross Profit is equal to Net Sales less Total Cost of Goods. In other words, it's the money remaining for other expenses and potential profit after Cost of Goods (including freight in) has been deducted.

Net Sales

- Total Cost of Goods

= Gross Profit/Margin

The bigger the number the better the chance, after deducting all other expenses, there will be a profit.

While the raw Gross Profit number is, of course, important, it is most typically expressed as Gross Profit as a Percentage of Net Sales. The higher the percentage the stronger the indication sales are growing faster than the Cost of Goods.

Gross Profit as a Percentage of Net Sales:

$$\frac{\text{Gross Profit}}{\text{Net Sales}} \times 100$$

A couple of examples may help in understanding this ratio. If Net Sales is $100,000 and Cost of Goods is $55,000, the Gross Profit is $45,000. In this case the Gross Profit as a Percentage of Net Sales is 45%. If Net Sales remains the same at $100,000 but the Cost of Goods is lowered to $45,000 the Gross Profit is $55,000 and the Gross Profit as a Percentage of Net Sales increases to 55%.

Tracking Critical Data
in Critical Times

Comparing store data with peer institutions can be an invaluable exercise. Creating a database of intra-store information can be equally valuable. But to make any comparative information accurate requires collecting data and making calculations in a uniform manner.

The following are the key data to be collected on a daily basis to make comparative calculations. It is important to note that there are multiple renditions of each of the following terms and calculations, but the descriptions below are those that are most easily and uniformly applied to the broadest range of museum store circumstances.

Data collection

Net Sales (A): At the core of financial and statistical comparisons is Net Sales. Net Sales is gross revenue less deductions for discounts, returns, sales tax, etc.

Transactions (B): This is the number of discreet individual sales run through the point-of-sale process. If someone only buys one item, that's one transaction. If an individual buys multiple items, that's one transaction. If multiple people each select something but only one person pays for all the items, that's still only one transaction.

Number of Items (C): This is the number of individual products sold regardless of price, type or how combined in a transaction. In point-of-sale systems these are discrete price look up (PLU) or stock keeping units (SKU).

Number of Hours Worked in a Salesperson's Capacity (D): This is a count of how many hours (sometimes approximate) are

spent by staff in a salesperson's capacity. For example, if the manager is on duty for eight hours during the day and three of those hours are spent on the floor selling, the three hours would be added to this total.

Visitation (E): This may be the most difficult number to standardize for inter-institution comparisons. Visitation is counted a hundred different ways in a hundred museums and many of these counts have purposes that affect how they are interpreted.

For the store's purposes the ideal count is the number of visitors who come in close proximity to the store when the store is open. The most important characteristic is consistency. One difficulty with counts of visitors is that in most institutions it does not include destination store customers – someone who has come to the museum just to visit the store and is typically not captured in visitation counts especially if there is an outside entrance to the store.

One attempt to create a tally that mitigates this problem is to count the number of people who cross the threshold into the store. Admittedly, if accurate, this would be an interesting and helpful number to collect. There are, however, several accuracy problems with this approach.

Counts using a handheld clicker or making hash marks on paper are notoriously inaccurate, especially if there is more than one entrance into the store. Double-counted and missed customers are common. In addition, trying to keep the count distracts the store staff from their far more important task of providing superior customer service.

Using an automatic mechanical counter presents different problems. It's difficult to adjust the count for customers entering and leaving the store, for children and others tripping the counter several times or for activity unrelated to being a customer. Sometimes only 40% or so of the raw count is used but that too is a guesstimate adjustment at best.

Another issue with counting the people coming into the store is that once the data is collected there are virtually no accurate and comparably collected results against which to make comparisons. It is my opinion that data collected in this manner meets the description of *Garbage In Garbage Out* and its only use may be for internal comparisons.

Store Size (F): Store size is a less reliable number in cultural commerce because few museum stores are built to an optimum size. In my layout and design consulting experience, even if initial plans for the size of a store are carefully calculated, between the time the initial plans are drawn and construction of the store is completed, the size is changed by demands from other museum departments and additional factors. This does not lessen, however, the value of calculating revenue per square foot by product category.

The baseline definition for the calculation of the size of the store is that space to which the customer has general access plus the cash-wrap area. The calculation should not include office, storage, shipping and receiving areas.

Data calculations

Revenue per Visitor:

$$\frac{\text{Net Sales (A)}}{\text{Number of Visitors (E)}}$$

The foremost benefits of knowing this number are:

- Along with all calculations using visitation as the divisor, this is a way to make reasonably fair comparisons among institutions of different sizes.
- This helps to evaluate the results in the store compared to changes in visitation. If visitation is down 15%, for example, but store sales are steady or down less than that, it's an indication the store is doing relatively well compared to the forces affecting visitation.
- It's a way to estimate future sales based on visitation projections. For example, if a blockbuster exhibit is expected to draw 50,000 additional visitors, taking the increase in visitation times the Revenue per Visitor is one factor to include in an estimate of revenue related to the blockbuster exhibit.

Revenue per Transaction:

$$\frac{\text{Net Sales (A)}}{\text{Number of Transactions (B)}}$$

The foremost benefit of knowing this number is as a measurement of the overall impact of factors in the store on the customer including the appeal of the product selection,

merchandising attractiveness, customer service, pro-active selling, retail pricing, general ambiance, etc.

Items per Transaction:

$$\frac{\text{Number of Items (C)}}{\text{Number of Transactions (B)}}$$

This is an excellent measurement of the application of incremental sales techniques. In other words, it helps to measure if the suggestive and add-on selling skills applied by your sales staff are affecting how many products, regardless of price, the customer is buying.

Transactions per Salesperson Hour:

$$\frac{\text{Number of Transaction (B)}}{\text{Hours Worked in a Salespersons Capacity (D)}}$$

This number is an excellent indicator of how busy the staff is and will help to plan staff coverage better than a history of revenue.

Capture Rate:

$$\frac{\text{Number of Transactions (B)}}{\text{Number of Visitors (E)}}$$

This calculation is an indication of the exterior appeal of the store including location within the museum and signage, plus most of the internal factors noted above as affecting the number of Items per Transaction. If your store has a

significant number of destination store customers, and their transactions cannot be distinguished from purchases by museum visitors, this number will not be an accurate measure of the capture rate of museum visitors.

Revenue per Square Foot:

$$\frac{\text{Net Sales (A)}}{\text{Size of Store (F)}}$$

Revenue per square foot is a standard measurement in commercial retail but is less valuable in cultural commerce because few museum stores are built to the optimum size. As noted above, this is an inconsistent number for inter-museum comparisons. However, as a comparative measurement of the performance of product categories within the store, it can be a powerful tool, especially when coupled with the parallel analysis of product category margins and other factors. In this case the calculation is:

$$\frac{\text{Product Category Net Sales}}{\text{Square Footage Devoted to Product Category}}$$

While, with the noted cautions, all the measurements above can be used to compare your performance to other museum stores, the greatest value may be for internal measurements that hopefully reflect steady improvement over a period of time. In the simplest terms, if the Capture Rate increases along with the Average Transaction the gross revenue will also increase.

STORE

DAILY DATA RECORD

Initials _____ Day of the Week _____ Date _____

Dollar Sales and Number of Transactions

	$ Sales	Trans.	Weather and/or other conditions
Noon			
3:00 PM			
Closing			
Additional			
TOTALS	A $	B	Total Units Sold C

Primary Sales Staff On Duty

Open to Noon _____

Noon to 3:00 PM _____

3:00 PM to Closing _____

Additional _____

TOTAL Salesperson (Paid and Volunteer) Hours Worked D

Miscellaneous Information (Holidays, Special Events, Vacation Periods, Visiting Groups, etc.)

Additional Statistics and Calculations

Visitor Count	E	Ave. Units per Trans.	(C÷B)
Average Sale $	(A÷B)	Capture Rate %	(B÷E)
$ Sales per Visitor $	(A÷E)	Trans. per Salesperson Hour	(B÷D)

Daily Store Record

Take a Commonsense Approach to Budgeting

There is no model or standard budget for museum store expenses because there is such a wide variety of how museum stores are organized. And as a result, there is no standard for profitability either. Some examples of variations include:

Rent: Most museums do not charge the store rent. Where the space occupied by the store is prime retail space, however, they sometimes do.

Staffing: The variety of staffing and compensation combinations is almost endless. Some museum stores are run by volunteers top to bottom and others have a full paid staff. Some stores have a paid manager, many have a paid manager and a paid sales staff for the difficult and less popular hours and weekends. Other stores may only pay for a business manager who handles the payment of bills and bank deposits.

Cost of Goods: Some museum stores absorb the full cost of printing exhibit catalogs and the production of proprietary product. At the other extreme, these products are paid for by the museum and provided to the store at no or subsidized cost.

Museum Versus Destination Store: Another difference results from stores where the vast majority of customers are museum visitors as compared to museum stores that are fortunate to have additional foot-traffic from non-museum (i.e. destination) customers. These different scenarios affect expenses as museums react to the needs of their visitors/customers.

With so many variations how should budgeting be approached? The best way is probably just to apply common

sense. Unless you are a new institution, start by looking at past performance. What were the expenses (and revenue) by line item? What is going to be different next year (exhibit schedule, for example) compared to the past year(s)? For which line items was there a major variance between what was budgeted for last year and actual results? What was the reason for this variance and will it have an impact on the next year? What should you do to adjust the budget from last year?

Get more substantial data where it exists. The *MSA Retail Industry Report* compiled by the Museum Store Association provides some information about compensation (Manager, Buyer and Product Development Specialist), fringe benefits, number of staff, and cost of goods and gross margin.

You can also contact similar museums (mission, size and location) with comparable staffing and other organizational characteristics and ask for their dollar amounts and/or percentages.

Realize there is only so much you can do. Concentrate on the big items with the greatest impact. Typically 80% of the expenses are loaded into 20% of the expense categories. In most museum environments these include cost of goods, salaries (and maybe benefits), product development and perhaps marketing. Sure, supplies should be kept under control especially when developing packaging, and you want to shop for the best credit card discount, but many expenses are directly proportionate to revenue (i.e. variable) and offer you less opportunity for influence.

In most cases, spending time calculating an Open-to-

Buy will have more impact on expenses and profits than any other activity. Second to that is an analysis of what you get in the area of customer service and pro-active selling for your salary dollars. In the very broadest of brush strokes (I really shouldn't do this), with caveats applied based on the variables above, the following is a rough guideline:

- 50% Cost of Goods including Freight In.
- 18 – 22% Salaries and Benefits.
- 10 – 15% Other Expenses.

Obviously, an all-volunteer operation will eliminate Salaries and Benefits as a cost. Stores that pay rent are usually associated with larger institutions, greater foot-traffic, or destination store status that often results in economies of scale or higher average transactions which helps to mitigate the rent cost.

Finally, budgeting is often a code word for reducing or controlling costs. If so, first pick your five biggest expense categories and examine them carefully looking for savings. Then, pick two other categories (such as marketing and travel) where some additional investment will result in greater sales and see if some of the savings from the first set of categories might be shifted to these areas.

Test How Low and How High Your Pricing Can Go

What should be the range of prices in your store? How many low priced items is enough? And how high can you go?

Specific numbers of how many low priced items you should have and how low is low, how high you can go and what the range should be is dependent on your type of museum, visitor and customer characteristics, the location of your store relative to other regular retail stores and the look and feel of your store, including the products and fixtures.

Let's look at each of these factors separately and then at some general rules applicable to most museum stores.

Type of Museum: Art museums, botanical gardens and arboretums, and architecturally-oriented institutions, for example, can expect to sell more higher-priced products than history, children-oriented and regional or county museums. The visitors to the first set of institutions generally will enthusiastically pay higher prices for beautiful and education-oriented products.

Type of Visitor/Customer: A distinction is made between these two types of buyers. If the museum stands apart from other institutions and shopping areas, and the store has not become a retail destination, the range of prices will probably be lower and the average transaction less because the primary population the store draws on is limited primarily to visitors, staff, members and volunteers.

Location, Location, Location: If, however, the museum is near an active retail core and/or the store has become a destination retail presence, nearly all measurements of retail activity can be elevated. In a sense, the throb of other

retail activity, especially if another store in the vicinity has higher-priced products, spreads energy to the museum store and provides cover for the museum store to include higher price points.

Look and Feel: How the customer feels in your store greatly affects how much they may be interested in spending. A great looking store that is well lit and maintained, with an attentive staff well-versed in key customer service skills, is going to sell more higher-priced products. On the other hand, scratched jewelry case glass and chipped fixtures and shelves make it much more difficult for customers to justify buying your highest priced products.

Retail Price Distribution Matrix: Using this chart (Fig. 1) as a graphic guide, you can create a visual picture for the spread of retail prices for the store as a whole or, preferably, by department. First, how is the chart created?

Use any similar form. The size of the form depends on the divisions needed to reflect the distribution of retail prices in some detail. This can also be done on a computer.

Divide the horizontal axis into equal retail price categories from the least expensive (left) to the most expensive (right). In general, $2.50 or $5.00 increments are best.

Use the vertical axis to count the number of products in each of the price categories designated along the horizontal axis. Count how many different products (SKU's/PLU's) there are in each price category, **not** the quantity of each product.

Connect the tops of the counts in each column to graphically depict the distribution of retail prices.

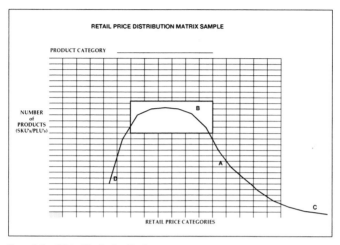

Figure 1: Retail Price Distribution Matrix

For established stores, the chart will reflect what is already in the store and so can be used as a base from which to consider changes. For new stores it can be a goal for the distribution of retail prices.

There are several key points I'd like to highlight about the results of this exercise.

Maintain A Seamless Flow of Price Levels (A): The modified bell curve that ideally results from this exercise should depict a seamless flow of price levels that makes it easier for the customer to spend a little more money. Through your sales techniques you can point out the benefits of more expensive merchandise, and if the price difference is reasonable, increase your average sale by moving the customer up a few dollars. Many customers may do the same without your assistance. Large price gaps, however, can make the job of up-selling much

more difficult. For example, if a customer is considering a $50 reproduction pot, there is a better chance they will spend more if there are additional pots available at $60 and $70 instead of the next more expensive one being $85.

The Bulk of The Product (B): The counts that form the top of the curve represent the bulk of your product. These items need to be in the price range that is most appropriate for your customer. There is no right or wrong range of prices, just appropriate, and it is different for every museum. A high-end store with wealthy visitors and members may have the bulk of the product priced from $35 to $95, whereas a smaller museum in an economically challenged environment may concentrate the bulk of their products in the $9 to $25 range. Museum stores that are primarily bookstores often have the bulk of their products in a lower range of prices.

Higher-Priced Products (C): It is my experience that most stores do not have a sufficient quantity of higher-pried products. In general, my advice is to slowly push the envelope of higher priced products until the customer resists. However, to make it a fair test and encourage these purchases, these products must be merchandised in an ambiance that enhances their perceived value. This ambiance may include glass instead of wood shelves, less dense merchandising, interpretive signage and better lighting.

Lower-Priced Products (D): It is also my experience that many stores offer too many lower-priced products. This does not mean that all levels of purchasing ability should not be represented in the store or that a store shouldn't have ten-

cent rocks and twenty-five cent pencils. This is just a question about how many lower-priced products is enough. I once worked with a store that had 373 different items (excluding books and postcards) priced below $5.00. Admittedly, although not a children's museum, they had a large children's visitation, but I thought this was an excessive selection of low priced products.

You can make sure the prices in your store are correct by knowing your customer, evaluating your product selection and merchandising and testing different pricing strategies.

Earn the Right
To Maximise Your Margins

There are two critical things to remember when establishing the retail price for merchandise, negotiating contracts for proprietary products, or setting consignment sales splits. One, pricing is a multi-faceted art not an exact science. Two, if you don't protect your profit margin at the top of the income statement there is no way to increase revenue as that income flows down through all the expense line items.

Regardless of the margins you determine to be right for your store as a whole, with variations for specific products and categories, setting the retail price is the only chance you get to maximize revenue through pricing. Sure, you can try to improve profitability by reducing costs, but every museum store with which I am acquainted has done about all they can prudently do to minimize expenses.

Let's start with an overall pricing strategy and then make exceptions to it as part of the process of refinement and customization. This strategy applies to items that are not pre-priced such as books and some carded items.

First, it should be noted that keystoning, the doubling of cost to determine the retail price for gift items, is dead. It died because there are many more costs besides the wholesale price of the product that need to be covered by the retail price. In addition to shipping, these costs include all the expenses incurred to get the product from the back door onto the shelf. I don't want to sound flippant, but if you can't mark-up a product more than double, find another product.

As part of an overall pricing strategy, determine the probable retail price of a product **before** buying it. In other

words, look at a potential product and roughly determine what you think you can sell it for in your store considering your visitor characteristics, the ambiance of the store, etc. Then, after you find out the cost of the item, if that probable retail price does not give you the margin you need, move on to another potential product. The time to determine the retail price is not when it arrives at the back door of the store or is ready to be entered into the POS system.

To establish the retail price, initially multiply the cost times 2.3–2.5 and then do one of the following:

1. Keep the retail price in that price range.
2. If perceived value, competition and regulations allow, increase the retail price to what the market will bear. Although competition is the ultimate restraint, if you have gone to extraordinary lengths to find unique, mission-related products, spent time training your staff on customer service and product knowledge, and have invested in creating a welcoming store environment, you have earned the right to maximize margins.
3. If perceived value, competition and regulations require, lower the retail to an acceptable price. Pricing below doubling of cost, however, should be a very rare occurrence and well supported with sound reasoning.

The 2.3–2.5 mark-up includes standard freight-in. In other words, the cost of standard/reasonable freight expenses are

absorbed into this mark-up without having to go through the calculations necessary to separately recover freight through an additional retail price increase. Extraordinary freight expenses, however, require increasing the retail price to recover those costs.

Many museum stores carry consignment items from valued artists with incredible talent. While a personal relationship with an artist can complicate the pricing strategy, it should be noted that over recent years the artist/store selling price percentage split has moved from 60/40 to 55/45 and now 50/50. The stronger the store's reputation, the more knowledgeable the staff and the more appealing the retail ambiance, the more artists will want to be represented in your store and the more you can charge for that privilege.

There are a few reasons to make sure you carry some relatively high-priced items. One, the sale of these items can turn an average revenue day into a memorable one.

Two, higher priced products enhance the feeling in the store. A visitor may not be able to afford a higher priced item, but they feel good about buying what they can afford in a store that has some higher-priced items for sale.

Three, you don't know the financial capabilities of customers walking in the door. They may have arrived in a beat-up Ford or parked a three-quarter of a million dollar RV in the parking lot. You also don't know what special meaning the museum has to a visitor. Perhaps they were married on the grounds, or visited the museum during their honeymoon or they or their family lived in town a long time ago and this visit

has special meaning. What we do know, is that we can't make that exceptional sale if we don't have the products in stock.

There are, however, two non-pricing caveats to successfully selling higher priced products. First, the sales staff has to have better, more in-depth product knowledge about these items in order to assist the customer to make this purchasing decision. Second, these products must be merchandised in an ambiance that enhances their perceived value. The bottom line (pun intended) of all this is that you must maximize margins at the top of the income statement if you want the highest possible profit at the bottom.

Managing Your Store like a Business: Control Your Costs, Especially Your Inventory

The overriding factor that affects the control of costs in smaller stores is managing the store like a business. Lapsing into an undisciplined approach to the store because "we're just a small (volunteer run) store" leads to increased costs and probably reduced revenues. In fact, only where quantity is an issue – such as to qualify for buying discounts – the process of controlling costs is virtually the same for big and small stores.

While many issues affect the control of costs, the following are some of the most critical. I believe just thinking about and discussing these issues, and thus raising the level of consciousness, will result in cost control. Evaluate the following to see if you are managing the store like a business.

Business Plan: Do you have a written business plan including a store mission statement? A cohesive plan of action is a stepping-stone to profitability.

Point-of-sale System: The use of as sophisticated a point-of-sale system as you can afford will help control costs by identifying and tracking key merchandise-related information.

Merchandise Buying Plan (Open-to-Buy OTB): This is the most important factor affecting the financial success of a store. Controlling inventory levels, which is by far the largest expense category, is critical to controlling overall costs. It is also important to balance margins as you buy. Generally lower margin, mission-related books, for example, need to be balanced by a selection of some higher margin categories

such as jewelry, hand-crafted and impulse merchandise. Finally, we all buy products that don't sell well. The negative effects of these purchases can be mitigated by managing sales effectively. A well-managed sale can reduce excessive stocks, maintain as much margin as possible and result in the sale of full-margin merchandise along with the sale items.

Income Statements: Are current and comparative income statements (profit and loss statements) prepared at least quarterly? These statements not only give you an overview of the store's operation but help to quickly identify developing problem areas.

Written Policies and Procedures: Written policies and procedures help to control costs by reducing wasteful actions. In addition, they protect the store by establishing standard routines that can be relied upon in case a key person is struck by the proverbial bus.

Job Descriptions: Making sure everyone knows what they should be doing improves efficiency, increases accountability and reduces costs.

Zero Tolerances: I don't care if the store is run by volunteers whom you have known for eons. A policy of zero tolerance for inventory and cash drawer discrepancies must be imposed to establish a consistent level of performance. This doesn't mean the staff has to hang around until midnight to balance a cash drawer, but at least written explanations of discrepancies should be expected. Remember, employees and volunteers, not customers, account for the greatest percentage of shrinkage (theft).

Data Collection: To go somewhere you need to know where you are. Keeping a good record of activity and results provides the background for making sound, cost-effective decisions.

There is no magic pill for controlling costs. Reduced costs are the result of adherence to sound business practices and constant vigilance to a myriad of little things.

Let the Customer Drive
Your Store Expansion

Let's say you're going to increase the size of your store from 650 square feet to 900 square feet: what are the merchandise and personnel projection issues you'll need to deal with?

The first issue you will have to address is the envy of your fellow museum store managers. If I maintained a list of the most frequent wishes of store managers, wanting more space would be at the top.

A great number of opportunities and chances for improvement will present themselves during the planning process for your additional space. I'd like to outline some of the key factors to consider.

The first focus of attention should be on the customer. Why is additional space available? Is the space being appropriated from other museum functions or is the additional space the result of a building expansion? If the additional space is the product of an expansion, will the expansion result in different customer demographics or are changing visitor demographics driving the physical change? Will this demographic change demand a different product selection? Will a change of product selection require customized or different fixtures? Will the expansion result in a different visitor foot-traffic pattern relative to the store? Make sure you clearly understand who the customer is and how they will physically interact with the store before designing your additional space.

When you start the planning process, I strongly urge you to think in terms of the entire 950 square feet. In the end, you may only be able to make changes to the additional 250 square

feet, but I find it helpful to initially think about the entire space as a blank slate. Sometimes, thinking in this global manner produces useful ideas that may not have the room to develop if only the incremental space is considered. This doesn't mean, however, all the ideas generated for the whole space will be able to be implemented. For example, the cash-wrap or the entrance may not be able to be moved, but the opportunity for a more cohesive space is greatly enhanced if you initially think of the current and new spaces as a whole.

The following ideas are usually not as important as the first two critical points, but they certainly should be considered.

Often, when the availability of more space is the opportunity, I first like to challenge the use of the current space. Before beginning to work on the layout for the expanded space take the time to evaluate the relative value of your current product categories (departments). Then evaluate additional categories you may want to add. These evaluations should take into consideration sales volume, margin, turnover and the space devoted to each category. Basically, you want to make sure those categories with good sales, turnover and margins are given sufficient space in the store – probably at the expense of space for product categories with less favorable characteristics. This evaluation will improve the productivity of the existing space and the use of the additional space.

This is also a golden opportunity to formulate a merchandising scheme that creates an ambiance which enhances the perceived value of your higher priced products. Carrying higher priced merchandise can increase sales and

the average transaction, expand margins, and enhance the image of the store and the museum. To do this well, you'll want to devote a sufficient amount of space so the merchandise doesn't look crowded, provide the flexibility necessary to display a wide range of merchandise and ensure the area has abundant lighting.

Other evaluations might focus on creating a department or two to be known for because of the depth, breadth or unusualness of the selection. You may also want to give consideration to carrying larger items.

As you go through the planning process, take the time to review the popularity of all, and especially permanent, exhibits. In all candor, although I fully understand the importance of curatorially significant exhibits, you should be most interested in those exhibits that are the most popular with your visitors – those that get your visitor's buying juices flowing. The exhibits and the relative popularity of exhibits may have changed since the store was initially designed. The purpose of this review is to make sure the product selection relates to the most popular exhibits and is well represented and presented.

Personnel needs are more difficult to project. How do you think the change in the store will affect sales? I'm sure you expect an increase in sales, but what will be the source of the increase? What will be the balance between increased average sales and an increase in the number of transactions?

If you expect most of the increase to come from about the same number of customers buying more, because there is

more to choose from, the customer servicing aspects of the store may not change substantially. If, however, because of an increase in visitation or a greater percentage of your visitors making purchases (capture rate), you expect an increase in the number of transactions, then customer service-focused activities may have to be expanded.

I believe the number of transactions, not dollar sales, is the best indicator of store activity. If the number of transactions increases then the size of the cash-wrap, the number of cash registers or point-of-sale terminals and other customer service oriented factors may need to be adjusted.

You have been presented with a wonderful opportunity. Although more of the same may be the best answer for the use of your additional space, I urge you to give serious consideration to taking calculated risks and doing something different with the space.

Deploy Sound Arguments To Renovate Your Store

Over the years that I have been a museum store consultant, three projects have been funded by grants. One was for the fabrication of fixtures for a new store and two were for store remodels. The grantors cannot be revealed, but the common thread through these and more traditionally funded projects was building a case that focused on justifying the work as an *investment* in increased revenue and visitor satisfaction, not an expense.

One of the most straightforward, business-like methods for financing a remodel is to include a line item in your budget that makes a monthly/quarterly/semi-annual or annual contribution to an account reserved for renovations some time in the future. It is common knowledge in retail that the physical appearance of the store affects how long visitors linger, where they look and how they perceive the value of the products. While it's possible that museum stores can stretch the time between updates a little longer because customers have different expectations, the core of the principle does not change.

While I'm not an accountant, I have seen some stores include this line item as an expense based on a percentage of revenue (and sometimes a flat amount) while others treat is as a below-the-line item also based on a percentage of revenue or flat amount. Two difficult parts of doing this are projecting how much you might need and when, and defending this pool of money from other uses as it accumulates. That's why it's critical for the museum administration to buy into the concept. If the administration recognizes that accruing funds is necessary to renovate the museum itself because of

the impact of visitor traffic on the physical plant, then the comparison to the impact the visitor traffic has on a relatively small space like the store will be easier.

The following are factors that can contribute to the investment, not just an expense, argument.

Product categories that can be particularly impactful in building a case for funds include:

Jewelry: Good-looking, well-lit and efficient jewelry cases are probably one of the best investments in a museum store renovation project. Generally, the category has enhanced profit margins, generated from a relatively small amount of square footage and is especially popular with female visitors.

Although expenditures for general maintenance projects are listed below, the replacement of scratched, especially horizontal, glass tops of jewelry cases can make a significant difference to the perception of the quality of the jewelry. The scratches, usually from rings and the use of the top as a drop zone for purchases, even affects the visibility of the jewelry.

Books: There is a direct correlation between sales and books merchandised face-out. This is especially true for the beautiful covers on art and botanical books. So, making sure you have enough linear feet of bookshelves to be able to face-out as many books as possible will enhance the look and revenue of this category and the image of the museum.

Apparel and Posters: Both of these categories sell better, and the transaction is more efficient, when the fixtures featuring these products facilitate self-service. T-shirts and sweatshirts, for example, merchandised by size and color

under an example of the graphic sell themselves. The same is true for poster displays that are directly connected to where the posters are merchandised.

Merchandising At Eye Level: Higher-priced and fragile products should not be merchandised near the floor. In addition to making them more vulnerable to breakage, the perception of the value of higher-priced products is diminished if they are merchandised too low. Getting them up and away from the dirt and grime of the floor and closer to eye level increases visibility and the perception of value which in turn leads to increased sales.

Attractive Displays: Part of effective selling in a museum store is to make sure the visitor, who may be tired from walking around your museum or who has a tour bus idling in the parking lot, sees relevant and attractive products regardless of how much time they have to spend in your store. One of the most effective tools for making sure this happens is having adequate – primarily horizontal – space where you can build displays and vignettes that highlight these products.

General Maintenance: Simply put, worn carpeting, chipped laminate, dated colors, yellowing and ineffective or insufficient lighting, marred wood and duck tape, used in any location visible to the customer, negatively impacts the capture rate and sales. You may see these conditions in mass-merchandised gift shops in tourist areas, but in museums, where visitors expect a higher level of quality and the retail presence reflects on the host institution, they should not be allowed to exist. Make sure to include close-up pictures of

fixture deterioration in your presentation.

The above and many other factors impact sales, but how do you build a case or make an impact on the decision-makers – be they museum administrators or granting institutions?

First, any presentation should be in written form. This may not be required by a museum, but is always a prerequisite of a grantor and in my experience a written request reflects more than what is written. It conveys that the process was organized and thought-through over at least the time it took to write the request. It also allows the decision-makers to take the information and present it to others in the decision-making process in the same form in which you made the request – rather than interpreting, summarizing or ad-libbing your case.

Another important component of a presentation are the financial projections. These projections can include broad comparisons to the MSA's *Retail Industry Report*, reports from specialty trade organizations such as those focused on jewelry, cards and stationery or gifts, and fairly constructed comparisons to the performance of other museum stores.

I think it's effective not only to include projections of increased revenue from renovations, but also to mention that the increased visual interest in the store usually results in visitors lingering longer, which leads to purchases in multiple product categories and improved capture rates. And don't forget to mention that since the museum store is often the last stop a visitor makes in the museum, it becomes part of his or her overall impression of the museum as a whole.

Finally, if there is any hope of turning the store into a retail destination, the physical plant must compare favorably to the regular retail world. Remember, the product and the experience are considered equal by the customer. The product selection may be wonderful, but if the experience isn't equally appreciated, the customer will buy less on this visit and return less frequently.

MERCHANDISING AND DISPLAY

Learn the Secrets
of Effective Displays

A great merchandise display will sell more merchandise, encourage visitors to linger, sell more merchandise, move customers through your aisles, enhance the image of your store and museum, sell more merchandise, and increase the dollar amount of your average transaction. Did I mention it can help you sell more merchandise?

Despite the obvious benefits, I've seen stores that do little more than throw things together for their displays. You shouldn't do that, and in fact, it's easy to do just the opposite. Here are some tips for creating the kinds of displays that will result in increased sales.

Plan it out: This must be the first step if you expect to make good use of the remaining tips. The first, and best, question to ask yourself is: What's the purpose of the display? Is its goal to introduce new products? Highlight slow-moving items? What merchandise do you want to promote? What's the theme?

Let the merchandise be the star: You want your customers to focus on the merchandise. As you plan your display make sure the merchandise, not the display itself, is the star of the show.

Buy products that show well: Other things being equal, if one product is packaged more attractively, has richer colors or a sharper design, buy the one that will make your selling and merchandising job easier.

Pay attention to the details (your customers will): I'm a backpacker. I learned a lesson a long time ago: when preparing your pack, if you take care of the ounces, the pounds will take

care of themselves. The same holds true with displays. If you use this checklist to take care of the details, you will end up with a powerful, revenue-generating display.

Color is arguably the most important factor, and it's inexpensive to change: Which of the following colors should you use to bring the right feeling to your display?

- Red: High visibility, emotional, good for accents.
- Blue: Cool, relaxing. Good for displays about air, water, distance.
- Yellow: Cheerful, represents vitality, comes through in poor lighting.
- Orange: Energy, heat, makes food more appealing.
- Green: Relaxing.
- Purple: Rich, dramatic.
- Black, white and brown: are neutral and can be used to soften bright displays. (A word of caution, use black sparingly.)

Lighting is another important factor:

- Use bright lights toward the rear of the store, no matter how small your space, to draw customers deep into the store.
- Use spotlights sparingly to make selected merchandise "pop". Don't overdo lighting highlights.
- Be aware of glare, light shining directly into customers' eyes, and shadows.
- Make sure jewelry has an appraising amount of light.

- Dark objects need more light.
- Glassware looks best when lit from the back or side. Customers will flee a warm store more quickly than a cool store. Make sure your lights don't make your store feel hot.

Use props for height and visual interest: Flat displays result in flat sales. Almost any kind of prop will add visual interest: acrylic stands and cubes, gift-wrapped boxes, driftwood, polished black river rocks, stacks of books, attractive packaging, logs, baskets, painted wood blocks, rumpled cloth, branches... the list is only limited by your imagination.

Product arrangement adds to the impact of the display: The eye naturally goes to the upper left or center first, so use this initial impression to your advantage. Here are some arrangement rules of thumb that can help you enhance the impression you want your display to make:

- Vertical lines create drama.
- Horizontal lines are placid, calming.
- Curves are soft and gentle.
- Diagonals are demanding and abrupt.

Use movement to attract attention: Use clear fishing line to hang a mobile or small compelling sign near the heat/ ventilation/ air-conditioning vent. The gentle movement will be eye catching without being distracting. When you combine it with good lighting, your customers will steer right toward it. Playing a sample video has the same effect and highlights

a specific product.

Use signage as a silent, never-absent, always-accurate salesperson: I strongly suggest clients incorporate informative signage in their displays. When you write the text ask yourself the following questions:

- Is it easy to read? Don't be afraid to use a larger-than-usual serif font.
- Is it easy to understand? To make sure it reads well, ask people unfamiliar with the products to critique the sign.
- Who is the target audience?
- When you write the description, assume that the customer has no prior product knowledge.

Keep your displays clean: Dust and dirt diminish the sparkle of your displays and give the impression that even your newest merchandise is shopworn.

Change something every week, and make the change obvious: If a display contains dark tones this week, use light tones next week. If you displayed a group of small items last week, fill the space with large items this week.

Allow areas for self-expression: Your staff includes people with great ideas and the ability to execute them. Let your people go! Empower your staff to build displays and give them the opportunity to buy into the success of the store.

Shamelessly steal good ideas from other museum stores.

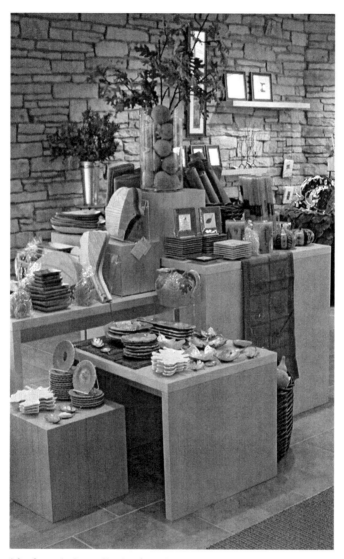

A first fixture that is a combination of nested parsons tables and cubes.
Morton Arboretum, Lisle, Illinois

Merchandising glass and ceramics against a backlit wall.
Denver Art Museum, Denver, Colorado.

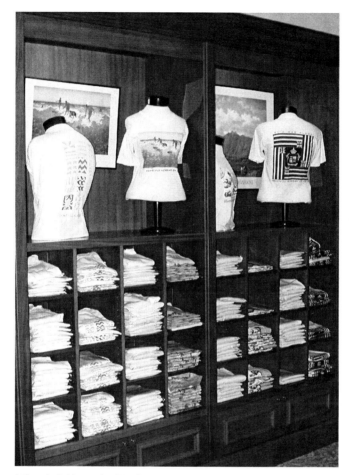

Self-service T-shirt merchandising by graphic and size.
Honolulu Academy of Arts, Honolulu, Hawaii.

ABOVE: T-shirts rolled, tied with raffia and merchandised by size and graphics. Historic Arkansas Museum, Little Rock, Arkansas.

BELOW: Dramatic merchandising of original art. Mosaic Templars Cultural Center, Little Rock, Arkansas.

ABOVE: The welcoming entrance to the museum store. Museo de Arte de Puerto Rico, San Juan, Puerto Rico.

BELOW: Merchandising outdoors. Morton Arboretum, Lisle, Illinois

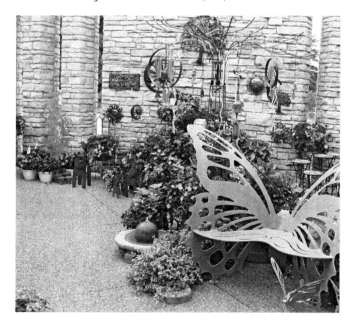

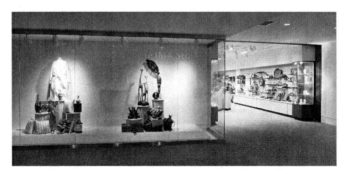

ABOVE: The welcoming entrance to the museum store. Indianapolis Museum of Art, Indianapolis, Indiana.

BELOW: Taking full advantage of the view from the museum store. Columbia River Maritime Museum, Astoria, Oregon.

ABOVE: Jewelry merchandising. Anchorage Museum at Rasmuson Center, Anchorage, Alaska.

BELOW: Merchandising hand-crafted products with explanatory signage. University of Michigan Museum of Art, Ann Arbor, Michigan.

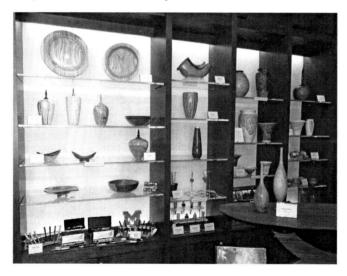

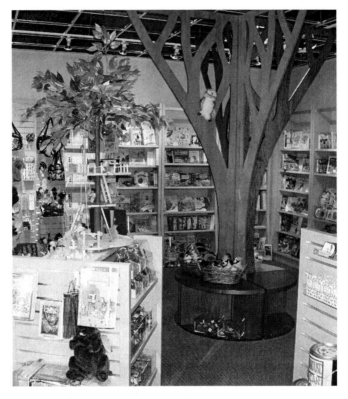

ABOVE: Children's corner using a stylized tree to identify and attract attention to the space
Morton Arboretum, Lisle, Illinois

BELOW: Effective jewelry merchandising, including interior jewelry case lighting, interesting
display forms and no price tags showing. Morton Arboretum, Lisle, Illinois.

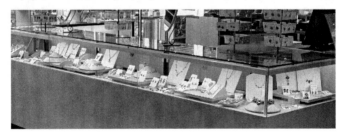

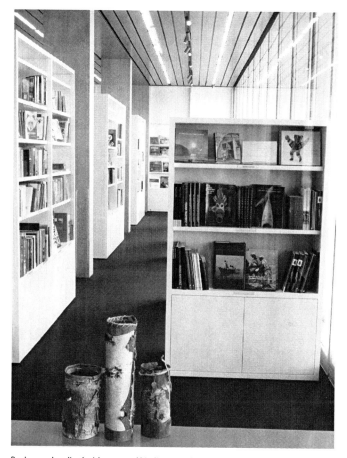

Books merchandised with cover and binding out, plus category signage.
Anchorage Museum at Rasmuson Center, Anchorage, Alaska.

Use Signage to Attract, Engage and Inform

The signage that works best in a museum store is different from that in regular retail because the customer is different. Museum store signage should blend with and enhance the image of the museum, but also needs to engage a customer who may have been reading exhibit descriptions for an extended period of time before entering the store.

Maybe the best way to approach this subject is to start on the perimeter of the museum's property and move inward toward the store.

In my home state of Oregon, a survey of arriving tourists was recently completed. One of the questions asked was: *What is the first thing you want to do when you reach your point of destination?* Sixty-two percent of the respondents said: shop. Well, if that's the case, then let's give the people what they want. Museum stores have a great reputation, so publicize the fact that you have a store by listing the store on other museum signage at the outer edges of the museum's property, especially near well-traveled streets and sidewalks.

We once worked with an aviation museum in a fairly remote location. As soon as we added Aviation Museum Shop, to the museum's already existing sign on the nearest road, there was more traffic turning into the property and an increase in museum visitation and store sales.

Although there is no substitute for a well-located store within the museum, interior directional signage is also needed. Regardless of how big or small your museum, add signage within the building guiding visitors to the store. Do not assume you don't need signage because your museum is

small or you think the store is so prominently located nobody could possibly miss it. Critical locations for directional signage include:

- Museum entrance.
- Exits from permanent and special exhibit areas.
- Where visitors linger, such as near foodservice, rest rooms, seating and cloak rooms.

On the exterior of the store, a sign above the entrance is important. In addition to that sign, another sign perpendicular to the primary flow of foot traffic may be more visible to the visitor and equally important.

Within the store, signage should be limited so whatever signage there is has more impact. In most instances, the identification of product categories is not needed. Hardly anyone needs any help to identify the book section, the apparel department or jewelry.

Within a department, however, any number of signage plans can assist the customer and build sales.

In most cases non-fiction books should be arranged by subject, fiction by author, and both clearly identified. Different languages and reading levels also benefit from signage. Please remember that many customers read at levels not directly related to their age. Chances for embarrassment are reduced by identifying reading levels by something similar to Beginner, Intermediate and Advanced, rather than by age.

Apparel should be arranged by type (T-shirt, sweatshirt, polo) and/or by graphic, but the types need not be identified.

To reduce refolding and assist the customer, sizes within each type of apparel should be identified.

Category signage that distinguishes between similar-looking products can be helpful. For example, signage identifying similar-looking, primary-colored, children's toy and game boxes might be categorized and identified by age.

Some individual products deserve their own signage. Small cards explaining the provenance of a product or group of products is a critical link in the continuing education responsibilities of the museum store. The connection of the product to the mission of the museum is of interest to the customer, extends how long the customer lingers, increases sales and is a strong UBIT defensive tactic. Similarly, proprietary product, product developed directly from items in your exhibits, should be identified.

For all museums, and especially museums that have a governmental association, it is important to tell the customer where the money goes. You don't want the customer to think the income generated by the store disappears into a deep, dark governmental budget. You do want them to know, however, that the *Income generated by this (volunteer assisted or run) store goes to support...* and then tell them about a specific, special project. When the customer realizes the money stays in the museum/community, it gives them a warm and fuzzy feeling and further distinguishes your store from commercial retail.

Special services should also be highlighted. *We Ship Anything, Anywhere* signs should be posted near heavy, fragile

and bulky products, and at the checkout counter, to answer possible objections to buying these products. Similarly, special order, gift certificates and the availability of other services should be promoted.

Certain legal verbiage, such as your return policy, is required in some states.

The perfect situation would be to have a store-specific design graphic that is uniformly used from curbside to checkout counter. Specific signage criteria should include image, color combinations, font and colors.

One other thing to consider when planning your signage is, who's the customer? Customers under 35 are more visceral and are greatly impacted by graphics. Customers over 35 are more intellectual and will take the time to read more. The three steps of signage are:

- *Attract attention*: The general attraction of the sign comes first, the message is second.
- *Engage*: An engaged customer will spend additional time on the focus of the signs. Clear, brief, professionally prepared and advantageously placed signs all help to engage the customer.
- *Inform*: This is particularly important in a museum store where signage is one small part of the continuing education program.

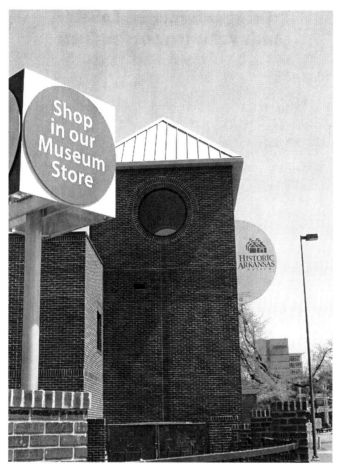

Exterior signage markets the museum store.
Historic Arkansas Museum, Little Rock, Arkansas.

Using Informative Labels Adds Value to your Products

Signage takes on special importance in a museum store setting. Often, because of the surge of customers when a tour group arrives, or just before they depart, or right after an audio-visual presentation has been completed, it is impossible to attend to every customer individually. In these cases, signage can be a critical and effective silent sales force. Signage can also be a useful tool to assist part-time and volunteer workers who, because of their limited work schedules, are not fully familiar with the merchandise.

One way to approach this subject is to explore the minimum signage that should be considered for the store. At the core, remember that the objective of store signage is to trigger buying decisions.

Product Relevancy: Wherever possible, a tag should be attached to products that establishes the relevancy of the product to the mission of the museum or to specific exhibits. (Fig. 1) Not only is this an effective UBIT (Unrelated Business Income Tax) tactic but it elevates the significance of the product to the purchaser and to the recipient if it is a gift.

Select Products: Typically, before they enter the store, visitors have already spent a considerable amount of time looking at exhibits in the museum. As a result, they will usually welcome anything you do to help them focus their attention rather than expecting them to visually sort through all your merchandise. Signage that calls attention to select products will simply increase the sales of that product. This extra attention can be focused on products of special interest, unusual complexity and high margin.

> **Northwest Indian Drum**
>
> The description should be 30 – 35 words long, using a 14 point serif font (a font like this with little feet at the extremes of each letter). Whenever possible, special emphasis should be placed on highlighting the benefits of the product.
>
> $375.00

Figure 1: Labels can elevate the product's significance

Highest Priced Products: I very strongly believe that all museum stores can sell more of their highest priced merchandise by giving them special attention. The limited use of signage enhances the value of your highest priced merchandise and will help increase unit sales. Signage alone however, will not increase the sale of these products – they must also be merchandised in an ambiance that enhances the perceived value.

The signs can be 3"x 5" or 4"x 6", all printed on the same distinctive card stock using the museum's logo, colors and fonts. For one client we numbered the signs, expanded the description length and suggested that customers seek out all the signs highlighting these special products. As a consequence, the customers lingered longer, focused on the highest priced merchandise and this resulted in increased sales of these and other less expensive products.

Non-Museum Events: Except for on-site museum stores (and satellites) that are located where they can take advantage of

foot traffic in addition to museum visitors, most customers are initially motivated to make a purchase as a reminder of their visit to the museum. A significant number of incremental sales can be triggered by prompting the customer to remember that the products in the store can also be wonderful gifts for special occasions. Displaying a few select products around a *July Birthday Ideas* sign will plant the notion that the merchandise in the store will make a wonderful present for Aunt Mabel's birthday. Equally effective is a sign that highlights *What's New* in the store because everyone likes being the first on their block to buy the latest merchandise.

Please understand, I am not suggesting that you turn your store into a card shop, with signage for every real and imagined event ever encountered by mankind. But when a customer is faced with hundreds of SKUs, especially after looking at exhibits, they welcome some guidance and it can be a win-win situation for the customer and your store.

Set Up an Efficient, Profit-Boosting Cash-Wrap Space

The cash-wrap design for small-to medium-sized museums that sell jewelry or other small relatively expensive items, include the following five components:

- Sales desk.
- Jewelry counter.
- Americans with Disabilities Act (ADA) service area/drop zone.
- Work space.
- Additional product merchandising space.

Sales Desk: The key design features of the sales desk component typically need to include sufficient horizontal area to efficiently accommodate the:

- Point-of-sale equipment/screen (one or more standard cash registers, sophisticated cash registers or computer point-of-sales).
- Cash drawer.
- Barcode scanner.
- Computer keyboard.
- Computer mouse and pad.
- Credit card swipe.
- Receipt printer.
- Telephone.
- PIN and signature pad.

Some of the above items may be integrated with other equipment, such as a credit card swipe being part of the keyboard, but one way or another everything has to be

accommodated.

This section should also include a smooth horizontal area, about 42" from the floor, big enough to accommodate a customer comfortably completing credit card slips, checks, contact information, etc.

An additional area, usually below the main surface, can be used for:

- Bags.
- Boxes.
- Tissue paper.
- Ribbons, stickers.
- Pens, pencils and all the other tools of the retail trade.

Bags, boxes, ribbons and stickers should be accessible without having to open doors. Pull out drawers are acceptable for pads of tissue paper.

Jewelry Counter: Unless your overall store is busy enough, or your jewelry sales are strong enough to physically stand alone with a salesperson devoted to this separate sales area, the maximization of revenue from jewelry comes from incorporating jewelry counters into the cash-wrap.

This is especially important because it allows someone working at the cash-wrap to offer jewelry customer service at the same time. If jewelry is merchandised away from the cash-wrap and a staff person is not dedicated to the jewelry area, jewelry sales can easily be half of what they could be. Jewelry requires intensive customer service and perhaps the

highest level of security in the store and greatly benefits from immediate proximity to where your sales people are most consistently located.

Some critical components of a jewelry case include:

- Interior lighting in the front of the case shining back towards the merchandise. Typically the lighting is located where the top horizontal glass meets the vertical front glass. The lighting fixture should be as small as possible while still providing sufficient light with the horizontal construction mullions blocking as little of the view of the merchandise as possible. A lighting fixture with multiple little light sources enhances the sparkle of jewelry.
- A depth of no more than 18" so it's easy to reach the jewelry merchandised toward the front of the case.
- Height of about 40".
- Locked access to the display case and storage below.

ADA Service Area/Drop Zone: This area is where customers place their purchases to start the checkout process and includes the proper ADA mandated height and other dimensions for a retail counter. This drop zone should send a clear signal that this is where product ready for checkout should be placed and where the checkout line forms.

Perhaps most importantly, it is this counter – not the top of the jewelry counter – that should be used as the drop zone. Jewelry is usually a top seller in museum stores and generates the greatest gross margin percentage. Anything that

interferes with a jewelry customer considering and buying jewelry negatively affects the revenue and profitability of the store. If jewelry customers are disturbed during their buying process by someone, for example, who wants to purchase a 75¢ postcard, and as a result the jewelry transaction is not completed, the financial impact is significant.

The bottom line is, unless a separate jewelry area can be justified, established and consistently serviced, jewelry should be in a high-visibility but quiet part of the cash-wrap.

Work Space: Every client who has been able to create a work space as part of the cash-wrap is now unable to live without it. This is a horizontal area, of almost any usable dimension, built to a comfortable working height, with a configuration of drawers and storage areas below. Some of these workspaces have been located against the back wall of a cash-wrap area located on a perimeter wall or as an island in a rectangular or U-shaped cash-wrap configuration.

These workspaces can be used as a holding area for customer purchase, as a staging area for products to be merchandised, a processing space for pricing, etc. The important aspect is that it's an area that can be used for many purposes without cluttering the jewelry counter, drop zone or other cash-wrap components.

Additional Product Merchandising Space: The fifth component of a well-designed cash-wrap is a space where product, beyond jewelry, can be merchandised. This may not be a big space but it can be used for impulse items, simple add-on products

such as gift cards and anything else you want the customer to see before paying.

A product category that is best viewed at a distance is two-dimensional art. If the cash-wrap is U-shaped and placed against a perimeter wall, the wall space at the open end of the U, above a height of 40" or so, is an excellent place to hang products such as framed two-dimensional art and quilts.

It is important to focus on the cash-wrap as you evaluate what can be done to improve a store, or design a new one. Of course the mission-related products should be the stars of the space, but they'll lose some of their luster if you don't finish the store experience with an efficient checkout process. One of the greatest frustrations of museum retailing is not when business is slow because of low attendance (pretty much out of the control of the store manager), but when attendance is up (think blockbuster exhibit) and you don't maximize the opportunity. When busy times come, you need to be ready to process purchases efficiently.

Part of the maximization process is understanding that regardless of how long the customer has been in the store, when the customer is finished shopping and ready to go, the customer is ready to go! The longer the customer waits in line, the lower their overall perception of customer service for the whole buying experience. It's a matter of what have you done for me lately!

Location

Through remodeling or as part of a new store design, you want to make sure the cash-wrap is located as far along the typical foot-traffic pattern through your store as possible without using ultra-valuable space in the front one-third of the store. The physical presence of the cash-wrap sends a subtle message that the buying experience is over and it's time to pay. It's OK to deliver that message, but it should be late in the shopping process and after the customer has had an opportunity to

browse the vast majority of the store.

Some people believe the cash-wrap should be as close to the exit as possible to reduce shoplifting. Unless eye contact is made during the shopping experience, placing the cash-wrap near the exit is rarely effective because there is so much going on that distracts your staff during the checkout process. If, as typical, the exit is also the entrance, then that location also uses up valuable merchandising and display space. The sightlines from the cash-wrap should allow you to balance security and customer service while not making the counter the first thing the visitor sees when they enter or look into the store.

Design

If you sell small and expensive items that need to be inaccessible to the customer, it's best to merchandise them at or very near the cash-wrap so you can provide attentive customer service to anyone who's interested. Many customers don't ask to see items they can't touch on their own, so if you don't react to their unspoken interest it will cost you sales. There is an inverse relationship between the distance inaccessible products are from the cash-wrap and revenue. The further away these products are from the cash-wrap, i.e., where most of your sales staff hangs out, the less customer service attention they receive, resulting in less than optimal sales.

Lighting should be bright so products on the counter and in glass cases look appealing and to make the transaction

process for the customer and salesperson comfortable. By far, the best lighting for glass fixtures comes from a light source within the fixture not external to it. In general, the internal lighting needs to be double the brightness of the store itself to reduce reflection.

There are an infinite number of cash-wrap shapes and locations. In smaller operations an L- or U-shaped counter along a perimeter wall might work well, providing checkout and merchandising space. Island cash-wraps can usually be built bigger, accommodate more point-of-sale (POS) positions and provide easier access for the salesperson to product that is inaccessible to the customer. Two L-shaped counters, configured in an interlocking configuration, is a way to have two access points; provide multiple POS positions; have space for add-on product displays and secure cases for more expensive products. If a curved shape is configured, with the curve facing the direction from which customers usually approach, it's a pleasing part of the store experience. A work and storage counter in the center of the cash-wrap area can provide highly usable, work, storage and sometimes, display space.

It's important, too, that the cash-wrap not be the first fixture a visitor sees when looking into the store. The cash-wrap does not have to be in the customer's face to provide a vantage point for a friendly greeting. The importance of the cash-wrap is perhaps best put into perspective when it is realized that every paying customer, regardless of what they buy, encounters this part of the store.

Consider Enhancing your Store's Ambience with Music

Does music matter in your museum store? There are many good reasons to include a multi-speaker sound system in the plans for a store. Done right, playing background music can make your customers more comfortable and increase sales by enhancing the ambiance and setting a pace for their movement through the store. If you want, you can affect how quickly people move along, how long they stay and how they feel in the store.

The psychological rule of incongruous expectations is the core for determining what type or pace of music to play. Generally applied, faster compositions should be played in less busy environments and slower music in bustling stores. If a store is crowded and playing fast-paced music it may move people along at the risk of giving the customer the impression of being rushed. Slow music in less busy stores may add to a feeling of sluggishness whereas livelier tempos will help enliven the environment.

Another general rule is that most adult customers like their music in softer volume (and there is less chance of it spilling into the exhibits) while shopping, finding that louder music just adds stress. Music can also subdue the noise of ringing phones, point-of-sale system error warnings, the conversation of other customers and the din from the lobby or other common areas.

What should you play? The golden rule is to play what you sell and sell what you play. In doing so, you will constantly promote your music selection and avoid legal issues surrounding the use and application of music in commercial

settings. I'm not a lawyer, but generally speaking if you are playing what you sell you are promoting your music selection, increasing sales and everyone including the artists benefits. If, however, you are playing music that you don't sell or from the radio, that music is being used to enhance your environment and sales without benefit to the artist and that may place you in violation of private and governmental regulations.

There are also many non-legal reasons to never play a commercial radio station. When playing the radio there is the potential for inappropriate music, commercials can break the shopping mood and the radio will rarely promote your product selection.

Multiple speakers help to even-out the sound source. Blasting music from one speaker makes it too loud near the source, too soft at a greater distance and does little to enhance the overall environment of the store. Multiple, wireless speakers around the store at soffit height will create a surround-sound quality while subtly affecting the sensual experience of the customer. And let's not forget your staff. This arrangement of speakers will allow them to better hear what's going on in the store without being blasted by music in one area.

To complete the technical aspects of the sound system invest in a high quality, multiple CD player. If you get one that plays five or more CDs there is little chance that you will hear a particular song more than twice in a day – a welcome improvement over the single CD player playing the same music over and over and over again. The downside of a

multiple CD player is that it is more difficult to identify for an inquiring customer exactly which CD or song is now being played. A list of all the CDs and the tray they are in will help. One last point, most CD players you can afford are not made to be played all day long every day, so consider investing in the warranty available at the time of purchase.

Let's make sure we distinguish the use of a sound system from a customer listening station. The goal of the sound system is to contribute to the ambiance in the store while promoting the music selection. The listening station is more focused on product selection promotion and is a convenient way for the customer to sample the product. There is no question that some sound emanating from the listening station will attract customer attention and increase sales. This sampling of sound, however, should not compete with the store's sound system. The listening station should have a small speaker that projects sound into a limited surrounding area or headsets. The newest, and hygienically safer systems have a sound dome above the zone in front of the station that creates a listening area where the audio sound can be localized. If only earphones are used to sample your selection fewer people passing by the station will be attracted to your selection and the number of people actually listening to the music is reduced. Although headphones facilitate more than one person listening to their personal selections there are concerns about health and hairdos that limit their effectiveness.

MARKETING

Remind your Customers That you Exist

How can you get the most return from your limited marketing budget? Effective marketing takes on different characteristics for different institutions and needs to be customized to be effective. So, in an attempt to be helpful to a broad range of museums, I'll list a series of principles (some presented as questions) to be approached as empty vessels which each museum can fill with characteristics of a marketing plan that are applicable to their museum, collection, visitors, location, and budget. The cumulative effect of this exercise can be an individualized outline of effective, low-cost, marketing ideas and approaches.

Who is the customer?

The first question that must be answered is who is the customer? A crystal-clear understanding of the characteristics of the museum's visitors and the store's customers is critical. Products can't be bought, retail price ranges set and marketing planned without this understanding.

Who is the best future customer?

Your best future customer is a current customer. It takes five to seven times more money to find a good new customer than to retain an established one. Do you know who they are by name and email address? (This is different and more detailed than understanding the characteristics of the customer as described above.) Of course, in a quick analytical snapshot, museums with heavy tourist traffic get a smaller percentage of their revenue from repeat customers. But, the longer the

time period over which the revenue stream is examined, the more it becomes clear that there is a core of repeat customers who are very steady buyers and you need to know who they are. The answer to this question is not simply that the members and volunteers are the best repeat customers. Some of them certainly are, but others not directly associated with the museum are often also part of this list.

To make effective and efficient use of this repeat customer list it should be segmented. The goal of segmentation is to approach different groups of repeat customers in a manner that maximizes your impact on their buying habits. One example of segmentation is represented by the Customer Chart (Fig. 1)

The top 5% of these repeat customers may be identified as being the best, based on total dollars spent and word-of-mouth influence in the community. They should be approached several times a year. The marketing focus should be on:

- Thanks for being a customer.
- Acknowledgement of their position as a special customer.
- Invitations to special events including trunk shows and demonstrations.
- Offer of rewards and possibly enrollment in a loyalty program.
- Early announcements of new items.
- Encouragement to bring in their friends.

The bulk of your customers for whom you have addresses (physical and/or electronic) may be occasional customers. But,

Figure 1: Customer Chart

because some visit the museum multiple times a year and thus frequently come in close proximity to the store, they should be reminded about the store, albeit less frequently than the best group. These customers may be both associated with the museum or just shoppers from the community. They can be enticed with some of the same and/or different offers listed above.

Museums may approach this segment differently, but the key point is to remind those customers who have already showed their support for the store through their buying, to come back again. One thing for sure, you cannot assume your repeat customers will come back again. You must remind them that you exist.

Repetition

One of the key elements of any marketing plan is repetition. Under the theory that not everyone is exposed to every

marketing tool you use every time you use it, it is critical to repeat your message.

Some repetition, such as ads in local publications, can be expensive, but other repetitive actions are considerably less costly. Less expensive possibilities include:

- Articles/ads in the museum's newsletters and other publications.
- At least the phrase *Museum Store Hours: ...* on rack cards and every other promotional brochure produced by the museum.
- Mention of the museum store in all museum literature and publications including catalogs, special exhibit promotions, school visitation literature, etc.
- Mention of the store as part of admission desk greetings and docent tours.
- Signage where visitors linger such as elevators, food service and near restrooms.

The consistent use of logo, colors and fonts are important parts of the cumulative effect of repetition. Remember, you will tire of a marketing program before your visitors and customers.

Create and Work Your Customer List

Working with the names of customers you already have will reduce costs and increase the response to your marketing efforts because they are already familiar with your store, are the easiest prospects to access and the least expensive to reach. When you add basic marketing principles to the mix, you'll have a marketing winner.

First things first

Before beginning a database and cross-merchandising marketing program you need to gather some facts so you know where to focus the plan and how to spend your limited resources. Some of the questions to answer include:

1. Who are your current primary customers? What are the characteristics of the customers that drive so much of your sales?

2. Who are your current secondary customers? Combined with the primary customers, it is not unusual for these two groups to be responsible for 70-80% of your sales.

3. What are the characteristics of desired new customers?

4. What do people know about your museum store? What's your image? Are you known for something?

5. What do you want customers and prospects to think about your store?

6. What do your current customers buy? List your best products in each of the following categories: Dollar sales, units, margin and turnover.

7. Who is your competition and why do you perceive them as competition? What distinctions do you want to make between your museum store and the competition?

Collecting names

To build a list start by throwing away the guest book you may be using. Names written in a guestbook are difficult to read and you have no idea, other than by zip code perhaps, about the quality of the contact. Instead, use a card handed out to your customers.

A couple of details. Use boxes on your card because people write more neatly in a box than on a line. Also, build a list only as large as you *will* contact not *could* contact. Having a name and not using it is useless. Keep culling and updating your list so it reflects the best of your customers up to a number you will actually use.

Marketing plan checklist

A checklist of some critical characteristics of a successful museum store marketing plan to apply to your database and cross merchandising efforts include:

- Making it a written document with measurable goals so results can be thoroughly evaluated.
- Examining opportunities and challenges such as:
 Potential competitive edge(s)
 Customer service
 Exclusive and/or proprietary product lines

Breadth and depth of product selection

Mission-related products

Superior quality products

- Clearly defining:

Objectives

Target audience

What you are selling

Call to action

- Focusing on revenue generating goals such as motivation for customers to:

Give you a try

Buy now, especially for tourists

Buy more per visit (linked with suggestive and add-on customer service.)

Think of you first (top-of-mind, destination store awareness)

Return for another visit

- Moving the customer through four important steps:

Get their attention

Create interest

Highlight the benefits

Stir to action

- Establish a schedule for executing the plan.
- Consistent use of logo, colors, font, etc.
- Repetition is an important part of the cumulative effect. Remember, you will tire of a marketing program before your customers and prospects.
- Budget and track your costs.

- Track and evaluate results.
- Giving full consideration to the needs of your top market audiences.
- Understanding what to advertise:
 Merchandise that sells well
 New merchandise that will attract attention
 Merchandise that reflects the mission and exhibits of your museum
 Brand names being promoted by the manufacturer.
 Seasonal items.

Going through this checklist for every database and cross-merchandising marketing effort will simply result in a more successful campaign and efficient use of your advertising dollars.

.

Use Email Campaigns
to Boost your Sales

In the face of social media opportunities such as blogs, Facebook and Twitter, isn't email outmoded? And doesn't spam make email ineffective?

The answer to both questions is no. The proven effectiveness of email as a direct marketing tool and the constant improvement of anti-spam software means it isn't dead yet and should be a part of your marketing campaign along with social media and other marketing tools. The focus here is on goals not technical execution. Once goals are firmly established it's easier to determine what needs to be done to get you to your objective.

A retail adage is, your best future customer is a current customer. Although museum stores may have a higher percentage of one-time customers, such as tourists, when compared to commercial retail, many of the rest of the museum store's customers are described by this adage.

Email Service Providers (ESPs) can be used to manage, track and evaluate email programs, but I'd like to suggest the development of a limited store-only contact list for special customers that you can manage yourself. Many of the following ideas are the same principles used in conjunction with ESPs, but the following, smaller and targeted plan can be put in place easily and produce results quickly.

What are the steps to putting together a successful email campaign?

Establish Goals: Typically the sharpest focus is on generating revenue, but the goals should also include relationship building and encouragement to current customers to bring

in new customers. Regardless of your goals, be clear about them. For our illustrative email campaign we will focus on keeping customers who have demonstrated support for the store coming back.

Identify The Target Audience: To whom are we going to send our emails? For our campaign the target audience is an in-house list of current store customers who, because of their expenditure habits or for other reasons established by the store, are part of a group with whom we want to stay in close touch. Expenditure habits can include overall spending levels or the frequency of smaller expenditures. Those on the list could also include people of influence within the constituencies important to the museum.

Decide How To Build The List: Identifying whom you want on the list is one thing, collecting names and contact information is another matter.

First, let's look at what the list isn't. It isn't a list of people who live in targeted geographical areas, who may or may not even know the museum exists let alone that there is a store. It also isn't a list that automatically includes the museum's members, volunteers and staff, although many of them may qualify for this select list. Instead, it's a narrow, targeted, subset of store customers whom we have invited to join or who have asked to be added to the list.

To collect names it is suggested to print good-looking cards requesting name, telephone number, email and street addresses, and to hand the cards to customers who meet the established criteria. When requesting permission to add the

customer's name to the list, advise them of the benefits of joining the list, which may include quick notice of the arrival of new products, announcements of special store events such as book signings, demonstrations and trunk shows, and perhaps early admission to sales. At the same time, pledge to never sell, trade or use their names for any other purpose.

How To Use The List: You must first become comfortable with the idea that those who have given their permission to be on the list probably want, even expect, to hear from you... so don't disappoint them.

Our example list may be used:

- As products arrive after attending MSA's Members Market, Expo and regional gift shows.
- In conjunction with the opening of special exhibits or toward the end of these exhibits to 'move' excess products.
- Just before sales.
- To announce special store events.
- Several times between November first, the year-end holidays and Kwanzaa to stimulate using the store for gift giving.

What The Emails Look Like: Set up your list so that it automatically personalizes the greeting by using the recipient's name. Remember, this is a limited list of friends of the store so you want to make it as personal as you reasonably can.

The emails that do best always include a call to action or create a sense of urgency – they are not just announcements.

Use groups of words such as *limited time, limited selection, best selection* and other motivating phrases in the subject line. The goal is to stimulate immediate action or at least the opening of the email before it is forgotten or trashed. Make sure the subject line is not misleading.

If you can, make sure the *From* line clearly identifies the store to immediately raise the comfort level of the recipient.

Emails need to look attractive and reflect the quality and branding graphics of the museum. Subtle backgrounds, easily readable fonts and maybe a high quality picture or two should be part of each email. To reduce the length and complexity, as measured by the size of the message, links to the store's presence on the museum's website can be added to provide additional information and reflect the context of the museum. When integrated with an overall retail or institution marketing plan, which may include always highlighting a continuing education item such as a book, it becomes part of the museum's content delivery program and is less likely to be viewed as just an attempt to get money.

Increase the chance of evading spam filters by not using the following, especially in the subject line: Free, $$$, !!!

Also, make sure you ask those on your list to add your email address to approved addresses at their ISP (Internet Service Provider) or within their mail programs.

Make it easy for recipients to unsubscribe.

Facilitate convenient contact by including an easily identified store email address (and a telephone number and the physical address of the store) in the body or at the end of

the text. Do not just rely on Reply as the way for people on this special list to reach you.

A link to recent emails can trigger, *I meant to get that!* responses leading to incremental sales. And, if that item is no longer available, attention to future emails is heightened so as to not miss future opportunities.

In every email, remind people that they gave their permission to be on the list and that the money generated online supports the institution.

Generally, you want to avoid sending emails on Mondays (there may be too many emails accumulated over the weekend, especially at business email addresses) and on Friday afternoons when people are focused on getting to the weekend.

Do It! It's easy, cost-effective and works.

There are No Pluses in Keeping Slow-Selling Merchandise

Is it proper for museum stores to have sales? And, if so, what's the best way to go about it?

First, let me put your mind at ease and assure you that you are not alone in asking this question, and yes, it is proper for a museum store to have sales. Excess inventory is a common problem among museum stores and retail stores in general and having a sale is one way to reduce overstocking.

Excess inventory has a debilitating effect on profit. Not only are funds tied up unnecessarily but inventory turnover is reduced, selection becomes dated because there isn't enough capital to buy new product, the old inventory reduces the perceived value of newer products, and merchandise has to be marked down, further eroding the bottom line.

Because of the significant negative impact that overstocking has on the profitability of a store, I think it is important to spend a couple of moments looking at how stores get into this situation in the first place. Less museum attendance than expected, adverse weather conditions, an overzealous publications department and other factors outside the store manager's control can result in an overstocked condition.

Simple excess buying also leads down this path. Often, taking advantage of too many inducements to buy more, such as quantity discounts, show specials, co-op advertising, dating programs and free freight offers, leads to excess inventory.

The most common reason for excess inventory, however, is not using a merchandise buying plan to plan purchases. If you are not using a merchandise buying plan you are robbing

the museum of the opportunity to maximize profits from the store. It is as simple as that.

Regardless of the reasons for the excess inventory condition, what can be done about it? If the overbought condition is focused on a relatively small number of products there are three things you can do before reducing the price. One, remerchandise the product. Move it up, down, sideways or across the store to a completely different location. Often, just putting a product in a different setting changes how it looks relative to other merchandise and sales will increase.

Two, suggestive sell it – call special attention to the product. Either build a display that includes the product or instruct your staff to verbally call attention to it. Making the product standout from other merchandise will also increase sales.

Three, incorporate the product into add-on selling devices such as gift baskets or groups of closely-related products.

If, in the end you simply have too much merchandise and you need to put it on sale, here are a few ideas on how to wring as many dollars out of this discounted stock as possible.

Don't be sentimental: If you are running your store like a business you can't be sentimental. Whether the product is ugly or your favorite, a slow moving product has the same financial impact on the store.

Do not maintain a constant sales table or area: Products in these areas quickly become shop worn and decrease in value at an increasing rate, while robbing merchandising space from higher margin, full price products. The appearance of

these products also lessens the perceived value of the rest of the store.

Do run sales periods two to four times a year: Sales are an overworked selling device so be judicious. When you have a sale, treat it like an event. In addition to a year-end holiday and/or end-of–season sale, put a positive spin on the reason for a couple more sales by making them volunteer thank you or making room for new merchandise sales. At this point, remember the reason for the sale is to get rid of old merchandise and raise cash to buy new, fresh products, so don't be shy about the discounts.

Put sale items toward the back of the store: Signage announcing the sale and a display of some items can be at the front of the store but put the sale items toward the back. In this way you maintain the appearance of most of the store and draw customers past regularly-priced product on their way to the sale items. Announcement signs should focus on the percentage discount (30%, 40%, 50% off) but every product should be clearly marked with the reduced price.

Your first discount is your best discount: This retail adage highlights the point that when the decision is made to put something on sale take the action necessary to get rid of it. The longer sale merchandise is on sale the less valuable it becomes. How much should you reduce the price? Enough to move the product out of your store. Remember the customer doesn't care how much you paid for a product, they only care how much they have to pay.

Surround sale items with high margin merchandise: Research

shows for every dollar spent on sale merchandise another is spent on full price merchandise. How many times have you been drawn into a store by a sale and walked out with full price merchandise? So, while the customer is going through your sale items make sure they see some full price items nearby.

Run a sale during times of high foot traffic: One error commonly made is to run a sale only after the season is over or when foot traffic is low. Running a sale into the teeth of heavy foot traffic will create general buying excitement, stimulate the sale of regularly-priced product and reduce your overstocked situation more quickly than trying to work through the stock when times are slow. Since most museums are not going to run advertising that will generate hordes of bargain shoppers, a good time to run a sale is when people are already in the museum.

Keep 'em guessing: Don't put the same type of merchandise on sale at the same time every year. You can repeat a good sale timing pattern but change what goes on sale during each sale event. Sure, it's logical to put certain items on sale at certain times, but the pattern for putting other items on sale should be varied to make it more difficult for people to plan their discount shopping.

Give it away, throw it away, write it off: There are simply no pluses to keeping old, worn and slow selling merchandise in the store, especially if this inventory is eating into your Open-to-Buy. Maybe the membership, development or education departments in the museum can use the products. Other merchandise can be donated to schools, hospitals and

libraries and written off the books. In the end, some items may simply have to be thrown away. If the overstocked situation is critical:

- Slow down buying – replenishing only best sellers and seasonal items. Do not stop buying entirely.
- Pick up the pace of remerchandising the store.
- Selectively cancel back orders. Suppliers interested in your long-term well-being should be cooperative.
- Send back merchandise when you must and if you can. Shipping and restocking fees can be less expensive than deteriorating value of excess inventory.
- Reduce retail prices into a sales peak.
- Market to your staff, volunteers and members.

Everyone gets into an overbought situation at one time or another. One measure of successful store management is how you get out of it. You can fret and worry, or you can take positive action that will alleviate the problem and may increase overall revenue. The course of action is up to you.

OPERATIONS

Use a Product Selection Matrix to Brainstorm Specialized Products

There is no question, the narrower the focus of your mission-related product selection, the harder you have to work to find related and seasonal product. But this statement of the problem also holds the answer. You just have to look harder.

The buying process includes three basic steps. These steps can be visualized as a funnel. Step one is coming up with good product ideas. This step is represented by the broad top of the funnel into which you pour as many relevant product ideas as you can generate. Step two is finding or creating the products that fulfil your ideas. This leads to a natural narrowing of the possibilities, some because of financial limitations, in the middle of the funnel. What falls out the bottom of the funnel, in step three, are the actual products to be bought in appropriate quantities.

In step one you should cast a broad net, searching for as many product ideas as you can find. Sources can include manufacturer and consumer catalogs; local, regional and national gift shows; websites, craft and street fairs; MSA's *Expo and Member's Market*; manufacturer reps, and other museum and commercial stores. The development of proprietary product to meet your product idea needs includes the same sources, plus ideas generated from store and museum staffs.

While the breadth of this process can be daunting, it will result in success. To assist in this process, we recommend the use of the following Product Selection Matrix (Fig. 1) to help organize the process and make certain relevant factors are taken into consideration.

A separate matrix is prepared for each product category or sub-category. On the horizontal axis, across the top of the matrix, list the most important product characteristics relevant to each category or sub-category. These characteristics can include price levels, reading ability, subject matter, type of product (such as earring, bracelet, ring or necklace for the jewelry category), seasonal relevance – you determine what is appropriate for each product category.

On the vertical axis, down the left side of the matrix, each product or group of similar products, being considered for the inventory, is listed.

An X is then placed under every product characteristic (across the horizontal) fulfilled by each product (down the vertical). This, of course, can be done on a computer or pencil on paper.

When the process is completed, a review of the matrix will give a quick read on the relative balance of the merchandise mix within each product category. Characteristics not fully represented in the product selection then become a description of the products that need to be bought or found. This exercise can be used by new stores to assure a fully representative opening inventory or by existing stores to periodically assess the relevancy of the product mix to the needs of the visitors and customers.

Step two repeats much of the process described in step one, except the scope is now significantly narrowed to those products needed to fill holes in the merchandise mix. While the sources may be the same, this time you are looking for

specific products rather than generating broad product ideas. One of our clients, with a very narrow institutional mission, visualizes using blinders as they go through the process to avoid being distracted from their mission. Now that you have a clear idea of your product needs, some previously considered products will be seen in a new light and will either become strong candidates for selection or more definitively dismissed.

After you have completed this process, product characteristic holes that are still not filled become one of the factors on which to begin consideration of the development of proprietary products. One of the advantages of developing proprietary product, of course, is that you are guaranteed the product will meet your narrow mission needs.

This process also results in a compensating advantage. The assumption is, because of the work you have gone through, your inventory includes unique merchandise. If this is true you have the opportunity to enhance your margins. While you still must be aware of general competitive constraints and the customer's perception of value the uniqueness of your merchandise eases the pressure from direct, comparative price shopping, and allows you to raise prices.

Step three – controlling inventory levels – regardless of the definition of your mission, is relatively easy, but it requires discipline. The primary tool you need is the consistent use of a merchandise buying plan, or as it is known in the retail world, an Open-to-Buy (OTB). The open-to-buy is simply the process of estimating sales for some period into the future

(typically, twelve to twenty-four months) and planning periodic purchases and delivery of product to meet those projections. The process also includes periodic adjustments to these calculations to reflect actual sales and inventory levels and other circumstances.

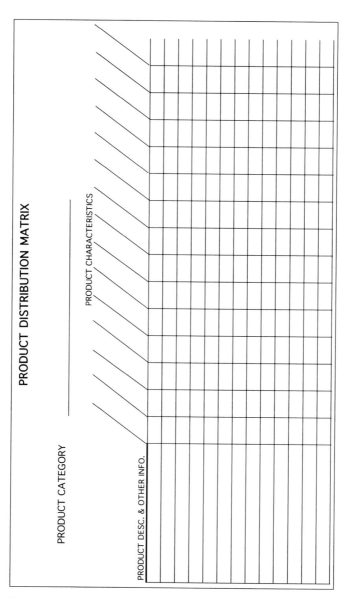

Figure 1 Product Selection Matrix

Eliminate Poor-Performing Products

Let's say that your museum is projecting a steady increase in attendance over the next few years, but the size of the store will not change. What should you be giving thought to in preparation for this increase in visitation? Many of the considerations listed in the chapter *Let The Customer Drive Your Shop Expansion* also apply to this situation. Especially important is an evaluation of the efficiency of the space you have. Under the scenario described, you must reduce or eliminate poor-performing products and departments and focus on those mission-related product categories that produce the biggest sales and margins for the space.

You, too, must evaluate the characteristics of the new visitors to make sure the products that occupy your limited space are the most attractive to your new constituency.

In addition, you should give consideration to design issues. Can you find additional storage space in the museum or off-site? Do you have storage space in the store that can be converted to merchandising space? On at least two occasions in very small stores we have converted the storage area at the base of display fixtures into merchandising space by removing doors and installing adjustable shelving. Being close to the floor, this is not the most ideal location for product merchandising, but it is fine for some merchandise such as kids-oriented products, technical books and tough PVC toys.

Also, make sure you review the efficiency and flexibility of your current fixtures. Can slatwall be installed where less flexible fixtures now exist? Can fixed shelving be converted

to adjustable shelving? Are there any walls or columns not merchandised to their full efficiency? Is there merchandise that is not accessible to the customer, which if made accessible, would increase sales?

Can you usurp some square footage outside the store for moveable fixtures that can be moved back into the store at closing? If you decide to expand the store presence, make sure to establish guidelines that will make the expanded presence a positive visual factor. Some considerations include:

If not everyday, how frequently can the store expand into the common area? What is the extent of physical encroachment? What standards of merchandising will be required? What fixtures can and cannot be used?

Another possible solution to the expanded visitation is the creation of an additional retail presence or kiosk someplace else in the museum. A kiosk focused on merchandise associated with a particularly popular exhibit, located very close to the flow of foot traffic near that exhibit, can relieve pressure on the main location and increase sales. The labor cost associated with this incremental location should be a major planning consideration.

Do make sure, however, you don't over-fixture the store, giving it a crowded feeling and denigrating the customer's shopping experience. I'd much rather see you restocking more frequently than trying to create enough merchandising space to hold all the products you need for an extended period of time.

Finally, don't forget about customer service issues. Training your staff in proactive customer service and selling

skills, and how to handle more than one customer at a time, will result in greater customer satisfaction and higher sales.

Managing Your
Customer Shipping Costs

How much should you charge for shipping and what should you base this on?

Perhaps the most basic decision to be made is, do you want to make money on shipping, just breakeven or are you willing to subsidize shipping costs to increase the number of store and online sales? This is an important decision because by some estimates, 63% of online consumers who did not complete an online order were dissuaded because of the cost of shipping their intended order.

In order to better understand the factors associated with this basic decision it's important to have the facts. Are you keeping track of actual shipping costs and what you are charging the customer? Fees collected from the customer for shipping should be recognized as a separate line item in the income section of your profit and loss statement. The cost of shipping to customers, discrete from other outbound shipping costs, should be reported as a separate line item under operating and other expenses. By comparing these two numbers over time you will know if you are currently making, losing or breaking even on customer shipping.

Regardless of how you determine the shipping cost (discussed below) it is also insightful to maintain a list of each shipped package along with the products in the package, the fee collected and actual shipping costs. An analysis of this report may help you identify a pattern of products that are resulting in a loss when you compare what you charged for shipping to the fee collected.

From my perspective, shipping charges do not have to be

designed as a profit center. Most online and catalog customers have experience with other companies or a sixth sense about what is a fair shipping charge. Pumping up shipping charges to generate incremental income may result in lost sales that could quickly total more than the incremental shipping revenue and result in poor word-of-mouth advertising. On the other hand, if you are selling unique, mission-related products that generate a strong demand without significant competition there is no need to subsidize shipping costs.

Online and in the store you don't want to slow down the transaction by having to go through a time-consuming procedure for determining the shipping cost. Leaving charge slips open until these costs are calculated and added to the transaction is becoming more problematic as concerns about credit card fraud grows. So, in the store you may want to consider creating a chart, partially based on your actual online shipping experience, that will allow you to apply an approximate shipping cost quickly and at the time of the transaction. This will result in some over- and under-charges but, if you are accounting for actual receipts and charges and maintaining a list of receipts and costs as described above, the chart can be regularly fine-tuned to become ever more accurate.

The shipping chart should be based on weight and general distance, not the dollar size of the transaction or the number of items. Studies have shown that customers, who are generally aware that shipping charges are based on weight and distance through their own shipping experience,

become highly irritated by situations where the higher retail value of a lightweight item, jewelry for example, results in a shipping charge that is perceived to be too much. In other words, if you are charging by the size of the transaction or the number of items in an attempt to simplify the process for your customers you may actually be losing sales or creating ill will. In addition, not charging by weight and distance, which are the main components in what you will actually pay to ship the package, may result in financial losses.

The measurement of turns is an important calculation. But like so many calculations, if the raw data is inaccurate, or the calculation is wrong or applied inconsistently, the result is useless. In fact, the use of inaccurate information will often lead to decisions that are worse than decisions made by gut feel.

Regular retail stores generally have one clear goal, to make as much money as possible, so comparing turnover rate data is a fairly reliable and useful activity. In many museum stores, however, the profit motivation is affected by other factors. Continuing education and community outreach goals have their affect on certain performance measures including turnover ratios.

A museum store that is willing to forgo some profit potential by carrying a wide selection of less popular, esoteric, or scholarly materials cannot be fairly compared with the store that caters solely to the shop-till-you-drop tendency of their visitors. The museum store that has a broad selection of proprietary items such as postcards and reproductions, that need to be ordered in large quantities to be able to sell them at a competitive price, should not be compared to the store that sells generic, easy-to-reorder merchandise.

Square footage is also a factor affecting turns. When designing new museum stores we rarely have the luxury of enough square footage for the projected visitors.

So, how should turnover data be used? I suggest you use it for internal monitoring of segments of your store as well as the store as a whole. The turns of individual items, different

product categories, products at various price levels, and the store as a whole can be compared to each other and to their own historical record. By segmenting the turn data you can set different values for each segment. You may well be satisfied with a 0.5 turn ratio for proprietary postcards, 2.5 for the store overall, and 6.0 for dinosaur-related toys. Unfortunately, in the vast majority of the museum stores that I am asked to review, turns are too low as evidenced by storerooms bulging with product, tired-looking merchandise, and the absence of goods associated with current exhibits.

In general, the higher the turns the better. High turns mean you are using your inventory dollars efficiently, your stock looks fresher, and you probably need less storage space. On the other hand, rapid turnover can put a strain on personnel who need to process more purchase orders and receiving documents, and deal with all the activity associated with frequent deliveries. Also, if you don't keep up with the work associated with high turnover you may lose sales because some popular items are temporarily out of stock.

If the turns are too low, however, too much capital is being tied up in inventory, which means the store is not contributing as much as it could to the museum, and may be short of cash that can be used to buy newer, more appropriate inventory. This situation often manifests itself in insufficient products tied into touring or temporary exhibits.

Planning and Setting Up Your Store

The keys to a successful store vary from early-in-the-process philosophical decisions to detailed operational procedures. In this chapter, I would like to review some of what my experience has shown to be the factors most critical for success.

Not all factors will be equally important. Some ideas may be impossible to execute because of size or budget constraints. For the most part, however, nearly every idea, with some modification, can be applied to new projects or existing operations to increase profitability. I suggest you use the following as a checklist of important philosophical and operational issues.

Philosophical decisions

When beginning to plan a new store or re-focus an existing one, basic philosophical decisions should be made and used as guideposts for the store. Some of the philosophical discussions may include:

Recognition of the Non-Economic Impact of the Store: Visitors usually spend more time interacting with store salespersons than with any other museum personnel, and the store often is part of the final impression visitors have of your museum. As a result, time and energy, primarily in the form of training programs, must be spent on customer service and pro-active selling. The personnel in the store, whether they are paid or volunteers, must be responsive to the visitor/customer, proactive in their application of selling techniques and knowledgeable about the museum in general and the

merchandise in particular.

Establishing a Clear Purpose for the Store: One of the most fundamental philosophical decisions that should be made in order for a store to reach its full financial potential is to clearly establish that revenue generation is the foremost goal of the store. Focusing on revenue generation does not mean the store will be stocked with inappropriate merchandise. In fact, focusing on revenue generation, augmented by consistent and diligent searching for mission-related product, will lead to the enhancement of two other important objectives – continuing education and community outreach.

Understanding the Impact of Visitorship: It must be recognized that the limits and upside potential of revenue generation are closely tied to the number of visitors to your museum. While the existence of mail order, e-commerce and wholesale sales, and/or a location that encourages retail buying unrelated to a visit to your museum can increase sales, most museums have to rely on visitorship. The good news is that museum-oriented shoppers are good buyers.

Location, Location, Location: Every obstacle placed between the visitor and the store, such as stairs or an out-of-the-way location, reduces sales. All things being equal, the best location for a store is on the right side of the route taken by the visitor when leaving the museum. At this point, both in time and location, the visitor has seen and been enthused by the museum and is at the peak emotional point for making a purchase to commemorate the visit, find a gift or continue their education.

Optimizing and Balancing the Size of the Store: A retail presence can be any size or shape. I use retail presence in order to dispel the notion that a store has to be a large defined space with four walls. The optimal size of the retail presence is a complex calculation. Dimensions must balance expected visitorship and cyclical patterns, an understanding of the characteristics of the visitor, the type of merchandise to be sold, available space and location, and whether the management and sales staff will be paid employees and/or volunteers. Almost any size retail presence, however, with the possible exception of a store that is considerably too big, can be operated profitably.

Operational issues

All operational issues come under one critical umbrella understanding: the store must be managed like a business. This includes doing most or all the same things a commercial retail store will do to maximize profitability. Key factors under the operational umbrella include the following.

Consistent Use of a Merchandise Buying Plan: Perhaps the most important operational requirement for a financially successful store is the consistent use of a merchandise buying plan, an Open-to-Buy (OTB). The OTB is the process of projecting sales for a future period, perhaps 12-15 months or more, and then calculating when, and in what quantity, merchandise should be purchased and delivered to meet these sales goals.

When I have been engaged to review an existing store with

the goal of increasing profits, the lack of consistent use of an OTB is a frequently identified problem and often results is very bloated inventory which is equivalent to precious cash reserves being wasted. In my opinion, regardless of how big or small the operation, an Open-to-Buy should be established and used consistently.

Write A Business Plan: The business plan should at least address the following issues:

- Mission Statement for the Store. This is a statement separate from the museum's mission statement.
- Vision/Identity Statement. Where do you want the store to be in five, ten years?
- Market Analysis. Who is the visitor/customer? What do they want to buy? How much are they willing to spend?
- Competition Analysis. To avoid losing the support of businesses in your community by competing unfairly, with the result of possibly raising Unrelated Business Income Tax (UBIT) issues, make sure your product selection is closely associated with the mission of your museum and special exhibits. This does not mean that you won't compete with commercial retail stores, but it does assure that you will be doing so on firm ethical footing.
- Marketing Plan. Regardless of how limited your budget, you must determine how the store will be promoted to tourists, locals, members, volunteers, supporters, board, staff, auxiliary – everyone who

comes in contact with your museum. Also, the existence of the store should be mentioned in every piece of literature produced by your museum.

- Management and Personnel Issues. There are many issues to be resolved in this area. It is key, however, that the manager of the store be given the responsibility and the authority to manage all aspects of the store. Management, and especially product selection, by committee is a formula for an indistinct product selection and financial failure. Also, it is better to make a retailer the manager and teach them about the museum, than taking a museum person and trying to teach them retailing.

- Financial Factors. First and foremost, require the use a merchandise buying plan. Secondly, plan to have income statements prepared on at least a quarterly basis.

Establish Volunteer/Employee Expectations Rules and Consequences: There are several steps that can be taken to ensure that your paid and volunteer staff are productive workers. First, emphasize the importance of the store to the wellbeing of the museum as a whole. During these times of increasing costs and uncertain funding, if the store staff understands the importance of the store to the overall financial health of the museum, their interest in their own efforts is heightened.

After you have laid this foundation, build on it by establishing expectations through written job descriptions and

empower the staff to do what needs to be done to meet these expectations. Perhaps the most encompassing expectation is that the store will be managed like a business and a professional attitude will be required from every staff member.

Invest in a computerized point-of-sale system: In general, a very strong case can be built for investing in a computerized point-of-sale system (highly sophisticated cash register) when net sales exceed $125,000. At this sales level, savings from inventory management, integration with accounting and membership programs, efficiency, consistent pricing, and other benefits will recapture the investment in a relatively short period. Choosing the right system can be difficult. My suggestion is to consult similarly-sized retail businesses in your area (not just other museum stores). There are many factors to consider, but don't forget to evaluate ease-of-use at the point-of-sale (especially if you have a volunteer staff) and local service representation. Also, in order to avoid finger pointing when your system goes down – and it will – buy your software and hardware from, and have it installed, by the same company. Finally, there is a tendency to not invest in sufficient training to maximize the use of the hardware and software. Sufficient training at the beginning of the process pays dividends throughout the use of the system.

Take regular inventories: Whether a point-of-sale system is used or not, hand-inventory the top sellers in your store on a regular basis. In most stores 30% or so of the product generates 70% of the sales. If you are out of one of your best sellers it has a greater impact than being out of a boring book.

Prepare written policies and procedures: Some key documentation includes:

- Policy and Procedures Manual.
- Customer Service/Sales Training Manual .
- Operations Manual.
- Marketing Manual.
- Merchandising/Display Guidelines.
- Store Operations Checklist.
- Job Descriptions.

Focus the product selection: The product selection must reflect the profile of the visitors and balance space and mission limitations. Perhaps the most important requirement to meet is Unrelated Business Income Tax (UBIT) guidelines. In general, in the United States, UBIT guidelines allow profits generated from the sales of merchandise to be free of income tax if the merchandise is closely related to the mission of the museum or a current exhibit. UBIT requirements actually are easily met and can help encourage store management to keep merchandise well-focused.

Merchandise focused on the mission not only limits UBIT exposure, but creates a retailing environment that makes each site unique and more appealing to the visitor. Even if it were not a tax code requirement, keeping the product selection focused on the mission of the museum is a key ingredient in creating a unique retail atmosphere.

In general, the most popular product categories are:

- Jewelry.

- Books, publications.
- Prints, posters, note cards, postcards.
- Apparel.
- Arts & Crafts.
- Three-dimensional reproductions.
- Children's merchandise.

Finally, become known for something. Develop one or two of your product categories so that because of the depth, breadth, or unusualness of the selection, it is a category for which the store has a reputation.

Provide a range of retail prices

The range of retail pricing should meet three criteria. First, make certain there are sufficient products at lower price levels so that all visitors, regardless of economic resources, can take away at least a token of their experience in your museum.

Second. The bulk of the merchandise should be in a price range affordable to most visitors. The greatest concentration of products should probably be in a price range, possibly $10 to $40, that is relatively easily accessible to most customers. Some customers will mostly look at products at the lower end of the range while others will be quite comfortable at the higher end.

Finally, it is important to have a selection of higher priced merchandise so that the customer who wants to spend more money for a special person or occasion can. Most museum stores leave money on the table because they don't carry a

broad enough range of prices. To be successful selling higher priced products, however, they must be merchandised in an ambiance that enhances their perceived value. Just buying a higher priced product and merchandising it with the other products in the store will not enhance profitability.

There are many additional aspects to a successful retail store. In my experience, however, the above are the most critical to financial success.

ABOVE: A dramatic garden shop built in a historic tobacco barn.
Yew Dell Gardens, Crestwood, Kentucky.

BELOW: A compelling store entrance.
Anchorage Museum at Rasmuson Center, Anchorage, Alaska.

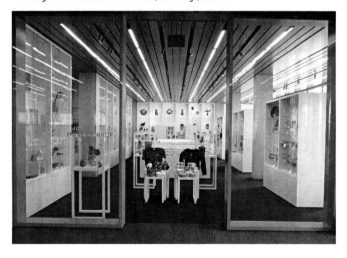

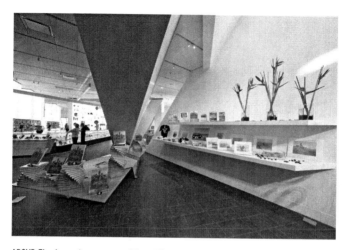

ABOVE: The dramatic entrance melding with, and using, the geometric elements of the Daniel Libeskind architecture.
Denver Art Museum, Denver, Colorado.

BELOW: Several forms of light: backlit columns and wall, freeform fixture above jewelry counter, and interior lighting in jewelry cases.
Denver Art Museum, Denver, Colorado.

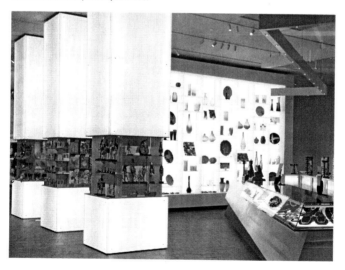

A variety of lighting sources, including ambient, track and recessed, to meet all merchandising requirements.
Honolulu Academy of Arts, Honolulu, Hawaii.

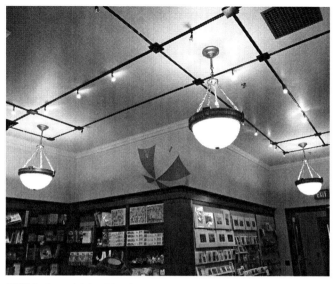

ABOVE: Replica period chandeliers for ambient light and track lighting.
Utah State Capitol, Salt Lake City, Utah.

BELOW: Natural setting and entrance.
Portland Japanese Garden, Portland, Oregon.

Recently, a shop manager commented to me, "In the past week, several silk scarves (about $70 each) and a beautiful nautical glass paperweight have been boldly stolen from our shop. These are not children, these are either senior citizens or groups of teachers who have been here for programs. I've been in the business long enough to know that shoplifting is a part of the cost doing business, but I am dumbstruck by the boldness of these shoplifters."

Let's get a discussion of a distasteful aspect of this topic out of the way first. By using the word *shoplifting* you are making the assumption that the missing product was taken by "senior citizens or groups of teachers". The use of the word shrinkage, however, broadens the potential reasons for missing product to include staff, paperwork errors and thefts executed before the product even reaches the selling floor.

It is important to use the term shrinkage because in a typical retail environment about 45% of missing product is stolen by staff, approximately 35% is shoplifted by customers and the remainder is paperwork errors – much of which will eventually be sorted out. I know, I know, your staff would never steal and I would agree that shrinkage attributable to volunteers and others not assigned to the store may be less in a museum environment, but unfortunately it does happen and you must be aware of the potential and take steps to deter the activity.

There are three areas in which to concentrate your efforts to reduce shrinkage with minimal cost and without resorting to the installation of electronic devices – fake or otherwise:

customer service, operations, and fixture layout and design.

Customer service

The least expensive and most effective tool to reduce casual shoplifting is proactive customer service, including greeting and making eye contact with every customer. I have chosen my words carefully because casual shoplifters are responsible for a significant percentage of theft, but a professional shoplifter or shoplifting team will hardly be deterred by eye contact. If a potential casual shoplifter feels they will be remembered there is much less chance they will shoplift. It is important, especially during busy times, that the staff on the floor come out from behind the checkout counter, are visibly identified with a nametag and/or a uniform way of dressing and walk around the store.

These staff people have four objectives. First, they can be busy straightening, merchandising and dusting; second, they should be available to interact with the customer by answering questions or assisting in any way they can; third, make eye contact with everyone; and finally keep an eye out for suspicious activity.

How returns are handled is another part of shoplifting prevention. Although I favor as liberal a return policy as possible, where shrinkage is a problem, primarily requiring a receipt for cash or store credit returns makes shoplifting that has the goal of converting the stolen product into cash more difficult.

Finally, consider renting an anti-shoplifting DVD or

having a law enforcement officer make a presentation to your staff to raise awareness of what to look for, especially the tactics of someone who is more sophisticated than the casual shoplifter.

Operations

You must make certain there is a division of responsibility and checks and balances in place throughout the receiving and storage process. As an extreme example, the same person should not order products, process receiving documents including the checking-in of shipments, update the point-of-sale system and approve invoices for payment.

In addition, the processing of in-coming freight before it is opened must be secure. Don't forget, it is easier to steal a box of twelve in the original shipping container than it is to take them one at a time after they have been merchandised on the selling floor.

If you use a point-of-sale system, a combination of surprise inventory status reports and visual spot checks can help identify situations and products that may be at higher risk of theft. If you suspect a specific staff person, you can run a targeted report or manually count before and after their shift.

Be careful, too, with the storage of your bags. If a shoplifter gets a hold of some of your bags and gets stolen property into them, there is much less chance they will be challenged when they leave the store because the assumption may be that it has already been paid for.

Layout and design

Shoplifters require privacy, so you need to eliminate or reduce the number of blind spots. The height of fixtures should increase as they are placed further from the entrance(s) and the checkout counter and toward the back and sides of your space. Being able to see as much of the store as possible from the checkout counter enhances customer service and increases security. Sometimes simply rotating a rectangular fixture so your staff can see down the long side of the fixture from where they congregate, such as the checkout counter, is all that is needed to dampen shoplifting. As a model, many convenience stores do an excellent job of fixture layout that maximizes visibility from one key location.

Mirrors that reflect blind spaces are relatively inexpensive, can be viewed casually as your staff move around the store and can be effective. There are some, however, who warn that shoplifters can also use the mirrors to their benefit.

In my opinion, in small and medium-sized museum stores, cameras are not that effective because there isn't enough staff to watch them consistently. If the cameras will be viewed with regularity by the security staff they can be a deterrent to shoplifting by giving the store staff a heads-up on suspicious activity that warrants heightened attention. If, however, they are rarely watched then their use is limited to evidence after the fact. While that can be helpful for prosecution, it is expensive and time-consuming to organize and keep a history of store activity. I think anyone with a minimum of shoplifting experience can spot a fake camera and some argue

they have the effect of challenging shoplifters to apply their craft more effectively.

In general, efforts to control internal shrinkage should be obvious and dramatic to highlight your commitment to inventory control. Anti-shoplifting efforts aimed at customers should be subtle so as not to offend the vast majority of visitors who do not have shoplifting on their mind.

Managing Children Well Makes Good Business Sense

One of the most important and rewarding aspects of successful museums is introducing children to the wonders of the institution. An important component of this process is encouraging children to take something home with them. Even a simple pencil with the museum's logo on it creates a potentially positive link between the child and the museum. So, wanting children to come to the museum and welcoming them into the store are goals worthy of your attention.

There are two steps that should be taken before children arrive at the store. First, appreciate the potential of children as customers and understand the marketing that is effective. The second step is to connect with the schools and lay the store visit groundrules before they bring the children to the museum.

The purpose of the communication with the school is to make teachers aware that children are welcome in the store under conditions you establish. This contact with the school can either be made directly by the store or as part of a pre-visit package prepared by the museum's education department. You may want to incorporate some of the following ideas in your store and then communicate them to the schools.

- To accommodate children from all economic backgrounds, have a broad price range of related merchandise available, starting at 25¢ or maybe less.
- To expedite the process, especially on exceptionally busy days, have pre-priced, (at even dollars, including tax) goodie bags available. This is also a good way to move slow-moving product. You want to make sure, however, the children are excited by what they get and

that it meets their sense of value.

- Explain that the number of children in the store will be limited to X at any one time, and only under the supervision of a teacher or chaperone. Although you will also be in the store monitoring the children's activity, it is important the teachers understand they have primary responsibility.

- When monitoring the children, stay in close proximity, make lots of eye contact and help demonstrate products. But don't be heavy-handed in your supervision, leaving the impression that you are overly suspicious.

- To shortstop some of the kids coming into the store, you may want to consider using a cart you can roll outside the store merchandised with the most popular children's products. This requires an additional staff person but reduces the wear and tear on the store, increases sales and allows older customers to enjoy the store with less distraction.

Before establishing guidelines for children, ask some teachers what would make their job easier and encourage them to bring their students into the store.

Is it worth the effort to encourage and accommodate children in the store? In my opinion, unequivocally, yes. Not only does this activity go to the heart of the mission of the store, but also it makes good business sense. Overall, children have significant money to spend. Their sources of

income include allowance, household chores, gifts, and work outside the home. In addition, conflicted parents are giving their children increasing amounts of money.

You may be more effective and enthusiastic about marketing to children when you understand that they represent three distinct consumer groups.

1. Primary Buyers spending their own money.
2. Agents of Influence who greatly affect how much money is spent on them.
3. Future Customers who will tend to repeat, as adults, activities they enjoyed as a child.

In the store:

- Merchandise children's products where a clear line of sight can be established from the cash – wrap, but out of the main traffic flow. And when possible, establish the children's area close to the entrance so children don't have to traverse the entire store to get to their department
- Leave room for the kids to cluster, because they will, and for others to get by.
- Children are primarily visual, so distinguish the children's area with color and a different floor covering.
- Add bean bags or smaller chairs to the children's area.
- Eliminate glass shelves, display components, and easily scratched surfaces, and lower the height of fixtures.

- Include an interactive activity or movement, such as a video, to attract and hold kids in the area.
- Display pictures of exhibits popular with kids to trigger purchasing ideas.
- Children like to collect things, so stocking a wide variety of similar products will satisfy their collecting appetite and increase sales.

When you have unruly children in the store, there is a one-word guide to how to handle them – diversion:

1. The best you can usually do is to try to divert an unruly child. You should do whatever you can to avoid embarrassment to the child, parent, teacher or chaperone. Diversion not only helps to keep kids under control, but also has the added benefit of freeing up adults to shop.

2. It is inappropriate for you to discipline a child. An incident is rarely perceived as the same by a parent or teacher, and the salesperson.

3. Avoid confrontation. If the adult supervisor feels offended by your treatment of the child, he/she may tell ten colleagues or friends about the experience. Negative word of mouth comments will damage the perceived friendliness of the store toward children. Remember that this may be the child of a good customer or influential supporter who is unusually rambunctious this one day out of the year.

Will having children in the store result in refolding more T-shirts, rebuilding displays, straightening merchandise frequently, and increased shrinkage and breakage? Probably, but it also a very rewarding melding of mission, sales and future growth.

How to Report on Your Store's Performance

From time to time, your director will ask if your store's doing better or worse than last year, and how it compares to other museum stores. So how can you best measure your store's relative success?

What may seem like a simple question has multiple simple and complex answers across a wide spectrum of measurements.

When this question is asked it is often implied that the desired comparison is to other museums. It is this comparison, unfortunately, that is the most difficult to make. The Museum Store Association has made the best effort at compiling and analyzing comparative data in their *Retail Industry Report*. But even in this serious effort discrepancies in definitions and interpretations can lead to misleading comparisons. Although this chapter will examine some inter-museum comparisons, the focus will be on intra-museum calculations.

For any calculations to be of value, it is important to carefully define the numbers that will be used in the calculation and the formula itself. Let's use dollars per square foot, a very popular calculation, as an example. If you are making a comparison to another museum or a group of similar museums, did they use Gross Sales or Net Sales as the revenue number? Are you sure only store sales were included or were e-commerce, wholesale or rental gallery sales, run through the store cash register, also included? The most accepted calculation is Net Sales divided by the square footage. What did the other museums include in the square

footage? Were storage or office areas included? How about that area outside the entrance to the store that is often used to merchandise special exhibit, sale or seasonal products? The most accepted definition of the square footage to be used in this calculation is the space to which the customer has general access plus the cash-wrap area.

One last caution, if any calculation includes visitors, who's included in this term? Are school groups included? Members getting in free? Volunteers working their shifts? Vendors visiting you and other employees in the museum? Destination shoppers not going into the museum?

So, rather than trying to sort out all this inter-museum potential for misleading information, I suggest you select from the following three approaches:

Use the MSA's *Retail Industry Report* as the best source of a broad range of benchmark data.

Connect with a small group of similar museums with which you can agree about the components and calculation formulas and use the results of this limited breadth but somewhat controlled sample.

Stick to comparisons within your store, such as the following, over which you have total control.

There are tens of possible calculations, but at the most basic level of measurement, the greater the percentage of visitors you capture and the more they buy with each transaction, the more revenue will be generated. So, the most fundamental calculations are Capture Rates, Average Transaction and Dollars per Visitor.

Museum Capture Rate. The percentage of museum visitors who make a purchase:

Number of Transactions
—————————————————
Number of Museum Visitors

Store Capture Rate. The percentage of people who cross the threshold into the store who make a purchase:

Number of Transactions
—————————————————
Number of People

(If the people count is taken by hand it is usually terribly inaccurate because the store staff is often distracted by all the other activities taking place in the store and miss or double-count customers. If an electronic counter is used, adjustments need to be made to the total to estimate the number of individuals coming into the store.)

Average Transaction. The dollar size of the transaction:

Net Sales
—————————————————
Number of Store Transactions

Dollars per Visitor. The expenditure in the store per visitor:

Net Sales
—————————————————
Number of Museum Visitors

Financial calculations and comparisons

Financial calculations range from the simple to very complex and also include inter-and intra-museum comparisons. Since the typical museum store profit and loss statement includes

three sections (revenue, cost of goods and other expenses) comparisons from each section can be of value. Most basic intra-museum comparisons are of line items from previous periods to current periods. Other than revenue, few lines are best compared by dollar amounts only. Most should be expressed as percentages of Net Sales. All inter-museum comparisons are best made using percentages rather than dollar amounts.

The most significant line items to use for comparison purposes are:

Category	Comparison to be used
Gross sales	Dollar amounts
Net sales	Dollar amounts
Total cost of goods (sold)	Percentage
Gross profit/margin	Percentage
Payroll and benefits	Percentage
Total operating & other expenses	Percentage
Net income	Percentage

Similar apple-to-apple comparison cautions as those listed above also apply to financial calculations and comparisons. Perhaps the most difficult line items to standardize are payroll and benefits. The variety of variations in these categories is almost endless. For example:

- The use of volunteers in management, buying, sales or support roles greatly impacts these expenses.
- Some institutions, such as those associated with universities and state governments, often have

considerably more comprehensive benefit plans with the associated increased costs.

- The use of part-time employees, students or interns reduces payroll and may eliminate the cost of benefit plans.

Regardless of the inter or intra, financial or other calculations and comparisons you make, make sure you also compare the level of visitation and place the results into this context. Even though inter-museum visitation comparisons, as noted above, have lots of challenges, everything you do with inter- and intra-calculations should be compared to visitation. Since the store is usually so strongly affected by visitation, and the level of visitation is pretty much out of your control, it should be included in every comparison report you prepare. For most institutions, the only fair comparison of store results is made within the context of the level of visitation.

Retail Selling is a
Tactile Experience

Retail selling is a tactile experience. The customer must be able to pick up an item and feel the weight of the crystal, see the detail of the carving, listen closely to the sound from the music box, smell a fragrance and sample taste a food item. It is these experiences that nourish the process of transferring the product from your stock to the customer's possession. Trying to sell products without the customer's tactile participation is very difficult and will not maximize potential.

Anything that makes it more difficult for a visitor to become a customer (poor store visibility or stairs, for example) or any obstacle placed between the customer and the product, simply diminishes sales potential. It is important to remember that, in general, visitors don't reach, bend, read or ask for help. Anything you do in your store that requires the customer to do one or more of these activities will reduce sales.

Many times products are put in protective environments in an attempt to reduce shrinkage and breakage. Clearly these are admirable objectives and worthy of attention – a lot of attention. Shrinkage and breakage, however, are part of the cost of doing business. Over-zealous attempts to reduce shrinkage and breakage, that also reduce the customer's tactile experience, will probably cost more in lost sales than they will gain in reduced shrinkage and breakage. In addition, most often the restricted product is higher priced, higher margin product, the sale of which can turn a nice day into a great day.

The same is true of negative signage: *Lovely to look at, delightful to hold, if you drop it, we mark it sold.* Signs of this

genre probably reduce breakage, but in addition to being frightful verse, also restrain sales.

When I am in my consulting role and conducting a store review, one of the steps of the review is to carefully examine all products that are behind glass, in locked cases or displayed out of the reach of the customer. I suggest you do the same thing in your store. The objective is to evaluate the actual need for these products to be in protective locations. Do shrink-wrapped model kits and book bags have to be out of reach? Sure, products such as collectibles, high-end jewelry and small reproductions may have to be in secure displays, but if they are, they require proactive, selling-oriented, counterbalancing actions.

The higher the percentage of product in protective display environments, the more attention has to be paid to responsive customer service. Your staff must be trained and retrained to immediately respond to anyone showing the slightest interest in products they can't reach. They must be there in a flash with a key to unlock the case, or an offer to bring products out from behind glass, or an invitation for the customer to come behind the counter so the subtle tactile experience can begin. Unfortunately, flash is not a word I associate with the movement of most sales personnel and especially volunteers. So you must have a balanced and aggressive program of evaluation of display environments, customer service/sales training and adequate sales coverage.

A museum store manager told me that they had a huge percentage of their product in glass cases because they didn't have enough money in the budget to hire adequate staff to

"protect" the product. Now I know it is difficult to convince some museum administrators to properly support the store, but I can absolutely guarantee that putting product in cases, combined with inadequate sales personnel, will kill sales. On the other hand, having enough well trained sales personnel will help to mitigate the effects of restrictive product displays. As an aside, *Don't hesitate to ask...* type signage is inadequate.

Another defense I have heard about restricting access is to reduce product wear and tear. Again, certain product should be in a protective environment, but if normal tactile attention to a product is affecting its appearance, it is probably more a symptom of inadequate inventory turnover which is magnified by the restricted access.

There are additional things that can be done to balance tactile experience and practical merchandising. Fragile products can be moved to a location out of the main foot traffic pattern, reducing exposure to the evil forces of breakage. Products that are most susceptible to shoplifting can be moved to where they can be easily watched: closer to the cash-wrap. One store kept some products in a beautiful, unlocked case in a high visibility location. The doors to the case were kept in a partially open position, inviting the customer's attention but not quite open far enough for the products to be removed. When the doors were opened further an appropriate sounding bell tinkled, alerting the sales staff to the need for customer service – and to the possibility of inappropriate behavior.

To address this issue, first, evaluate your current

merchandising and display program. Second, remerchandise products that do not need to be in a protective display environment. Third, make sure you have adequate staff to provide responsive customer service for the product kept in a protective display environment. Finally, train and consistently retrain your staff in the customer service and selling skills that enhance natural, tactile buying habits.

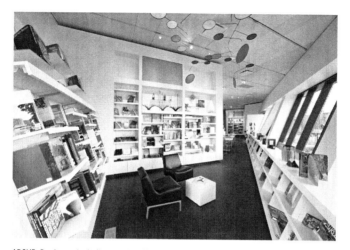

ABOVE: Book area including seating. Note the use of canted walls that were part of original architecture. Denver Art Museum, Denver, Colorado.

BELOW: Merchandising books. Daniel Stowe Botanical Garden, Belmont, North Carolina.

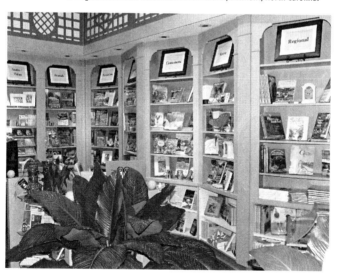

A request for proposal (RFP) is used when you want competitive bids for a project of just about any kind. This could be a point-of-sales system (a perfect project for an RFP) or retail consulting, development of a specific proprietary product, creation of a web site, fixture fabrication, etc. Since many museum store managers have an earned income responsibility beyond the retail presence, the following, used as a checklist, can also be applied to foodservice and facility rental.

Although often used for larger projects, museum rules, state laws or grantors may require an RFP before providing funding. Note, too, that an RFP for a service is written differently than that for a product, but the following will trigger points to consider for both types of projects. The points below intermix how you prepare and evaluate your RFP.

Compare apples to apples
The RFP has to be written carefully and in a manner that results in all respondents having the same understanding of what you are seeking, so they can prepare a response that can be fairly compared to all the other responses. Although this requires the responders to read the RFP carefully, how you write the RFP is the first and most important step toward this goal.

A fair and comprehensive comparison should include costs and other financial considerations, background of the responders, experience in the exact type of service or product you are requesting, operational ability and the capacity to get the job done well and on time.

What information you should provide

Full contact information for the institution and the key personnel involved in the RFP process. This primarily includes those who can be contacted for clarifications or additional information. To be fair to all responders, any request for additional information or clarifications from one responder should be disseminated to all. In some instances the members of the evaluation committee making the decision are not disclosed to avoid inappropriate pressure. Make every effort to avoid telephone calls and/or email communications directly with individual responders; all inquiries should become part of the routine Q&A that is collected, answered and distributed to all responders.

- The institution.
- Institution's title or number.
- Since some of the responders may not be familiar with your museum, include material that will introduce the institution and convey its culture and personality. Photos, renderings and institution collateral material including the mission statement can help to do this.
- A user-friendly, easy-to-read and understandable RFP that has not been written like a contract. (A contract will be written after a provider has been chosen and before work begins.)
- General overview of the project and how it fits into the bigger picture.
- Museum's financial goals and expectations (or budget if capital expenditure).

- Specific list and description of all the aspects of the RFP to be included in the response.
- Clear expectations including format (binding, printing, executive summary) and organization for the response, number of copies to be submitted to whom and where and by what date and time.
- The timetable the institution expects to keep regarding the RFP process.
- The timetable the institution expects the service provider to meet after the contract has been awarded.
- Financial submittal form(s) to make internal side-by-side review and comparison easier.
- Some legal information about protection of bidder information, equal opportunity statements, etc.

What to ask for from responders

- Name, address, contact information, size in terms of personnel, licenses or certifications.
- Relevant history of the company.
- Detailed experience and specific information about similar past projects including contact information, size, current status of projects. Make sure to get information about projects within the last two to three years.
- Complete and clear description of how the work will be done.
- Complete and clear description of the deliverables.

- Who from the company will be assigned to the project.
- Who from outside the company may be called upon to assist.
- References – and be sure to check them. Ask the referees about the success of projects, timeliness of the consultant and the general working relationship.
- Onsite visit before submitting an RFP. This provision is often associated with larger projects where the cost of a trip is justified by the potential size of the contract. Be aware that this requirement may limit the interest of responders to those located closest to you.
- Pricing by segment of the RFP not just for the project as a whole.
- How any additional fees will be calculated if the project is expanded.
- Estimate for reimbursable expenses including travel-related costs.
- In addition to specific information, it is helpful to ask for a statement that helps you evaluate how the responder communicates.

Who to ask to respond

Research the field of qualified responders thoroughly before submitting the RFP. You don't have to send the RFP to everyone on the list but you don't want to miss a key candidate. You can make pre-judgments of qualification and experience but don't

limit yourself to a geographical area because you think others outside that area will be too expensive. Wait for the proposal before making that judgment.

A way of limiting prospective respondents to only those that are really interested is to attach a reasonable fee/charge for the cost or printing and shipping of an extensive RFP ($25 to $75).

Distribution and receipt

If distributing electronically be sure to ask for confirmation of receipt.

If distributing a hard copy of the RFP package, distribute via FedEx, UPS or similar carrier to get a record of receipt to avoid we never received it disputes at a later date.

Be clear that any proposal received after the date and time in the RFP package will be returned unopened via guaranteed delivery and receipt.

Get real

When evaluating an RFP response you need to make sure:

- Its recommendations are realistic in terms of revenue, cost and profitability projections. All financial projections need to well documented.
- Any assumptions are realistic and in concert with other responders and your understanding of the facts.
- Make sure you filter the response through logic, your experience and the culture of your institution.

- Talk to your peers at other institutions about the responders; this is the best way to gain confidence (or not) with the three points above.

Be thoughtful

Preparing a response to an RFP takes a lot of time and work. Keep the responders informed about the process, especially if the decision-making process is taking longer than you expected. Advise all responders about the final decision or at least that the process has been concluded... and thank them for their submission.

Don't be a Storage Space Hog

How much backroom storage space should your museum store have?

The smaller the space devoted to storage the better. In these times of pressing need, conservation of space, like the conservation of capital, is an important consideration to museums. While the museum shop, like other departments in a museum, typically doesn't pay rent for the space it occupies, there is still a non-monetary cost to the museum for this space. Although the museum store is one of the few revenue generating aspects of a museum, this does not give the store license to be a space hog.

Another reason for a conservative approach to the use of space for storage is the financial impact of inventory on the profitability of a museum store. One impact is revenue-based and the second is an expense. The revenue issue is simply the value of selling space over storage space, although merely having more selling space does not directly correlate to increased sales.

The second impact of space allocation on the profitability of the store is the expense associated with merchandise on hand. In addition to the merchandise on the floor you of course need back stock, and you need more during busy seasons. Inventory, regardless of the location, however, has a real cost associated with it. You can gain an insight into the cost of your merchandise on hand by calculating inventory turnover rates for your store as a whole and for key product categories.

Inventory turnover is calculated by dividing the annual

cost of goods sold by the average inventory at cost. If your annual cost of goods sold is $100,000 and your average inventory at cost is $40,000, the turnover is 2.5 – a good number. Although we visualize turnover as the rotation of merchandise through the store, it really is a measurement of the efficient use of capital. It measures how many times your inventory dollars are used during a year. It is one of the natural laws of retailing that inventory will increase to fill the available storage and selling space. Good financial management practices, including the more frequent placing of smaller orders, and a properly sized storage area will help keep inventory at profit-enhancing levels.

So, how big should a storage area be? Although there are some general rules that can be applied, the primary determinate is sales level not the size of the selling space.

Additional key factors include:

- Number, kind and quantity of proprietary product for sale and imprinted packaging materials. If you have developed a considerable number of proprietary and packaging products such as postcards, T-shirts, posters, three-dimensional reproductions, and bags and boxes, the space needed to store the quantities you had to produce to get the cost down will require additional storage space.
- The size of your largest products also has an impact. If you sell reproduction furniture or statues, for example, you will need more space.
- Where are the receiving, pricing and shipping,

including internet sales functions performed? Is this done in the storage area? If so, that will require additional space.

In general, I recommend you start planning your storage space needs at 25-35% of your selling space. Then adjust your plans for the factors above and take the time to measure in terms of linear, square and cubic feet, some specific needs. Then make sure the fixtures in the storage area are fully flexible to accommodate changing inventories. Also, don't forget to take into consideration predefined architectural elements such as beams that may affect the efficient use of available space. You may also want to consider splitting your storage locations to conserve prime square footage close to the store. One storage space, of course, should be immediately adjacent to the selling space for frequent restocking purposes, but a second, less frequently accessed location, could be somewhere within the bowels of the museum.

Is Using an Outside Inventory Service Beneficial?

What are the pros and cons of using an outside inventory company for your inventories?

Perhaps the best way to address this question is to go through the stages of a typical physical inventory count and determine, step by step, if it is something you can do yourself or if you need to engage an outside company.

Step One – Preparing for the Inventory: During this time many things can happen. It is not unusual to run a sale to reduce the number of items in inventory. The focus of the sale is usually on slow sellers, obsolete inventory, product lines in which only a few odd items remain and categories where there is simply too much inventory. Products that are going to be written-off may also be processed at this time, although some recommend writing off inventory after the count.

Also during this period, all the nooks and crannies in which inventory is stored are identified and an effort is made to organize the inventory so that it is easier to count.

An outside company does not have the location and product knowledge to be able to do this. So, regardless of the decision you make about who is going to take the count, this is an activity that you will have to complete.

Step Two – Print a Current Inventory: Even when scanners are used to take inventory, it is not unusual to print an inventory to make certain all items believed to be in inventory are counted, or at least looked for. The organization of this inventory printout is usually one that assists in the counting process, i.e. it is organized by department/category or by the contiguous department/category layout of the store (bin number). And,

no matter how mechanized the counting process, it has been my experience that some pure hand counting is always done. Make sure all printed sheets are numbered so they can be accounted for at the end of the inventory. It is also helpful to have the before-inventory quantities included in this report. Wide discrepancies between the printed inventory and what is initially counted will often spur an immediate search for additional product or for an answer to the discrepancy.

The printed inventory, whether it is used by an outside company or not, will come from your inventory management system, be it paper or point-of-sale system based, and will be prepared by you.

Step Three - Preparation of Written Instructions: If you are doing the inventory this is a must. If an outside service is used and they are using only their own staff this is their issue. If a service is used and you are providing some or all of the staff it is important the staff clearly understand the instructions.

Step Four - Take the inventory: This is the stage at which an inventory service can be most useful. A service will approach the count in an independent manner and because of their experience, in an organized way that should result in a very accurate count of the entire inventory you have identified. Their experience and organization will make sure areas are counted separately and marked clearly so they are not counted more than once; examine case goods to make sure those counts are accurate; have sufficient personnel to do the count in teams, do test recounts, and remove any counting responsibility from managers and buyers who might have cross purposes.

They will also probably do it faster than your pizza-and-cola-fed group of staff and volunteers. Another advantage is, because they are outsiders, they may see the entire inventory situation in a different way that could have other benefits besides an accurate count.

On the other hand, the combination of some people who have taken inventories before, with the aid of scanners that download counts directly into inventory management software, and now the use of mobile devices, the technological edge is no longer strictly in the court of the inventory service. You must also consider the cost. Most companies have a smorgasbord of services, many with significant costs that can add up to a sizeable expense.

Step Five – Review and Finalize: After the initial count has been completed, some crosschecking, random recounts and recounting of products that have suspicious count discrepancies will take place. While the focus of this step should be on pure recounting, it is also a time when subjective inventory issues are raised and considered by management.

Certainly an inventory service will be helpful to get independent recounts, but any subjective considerations will have to be made by management.

Step Six – Printing Valuation Report: After all the information has been entered into your inventory program (paper, computer worksheet or point-of-sale system) a report valuing the inventory at cost and/or retail is prepared. The client usually prepares this report, but given sufficient information the inventory service can also prepare it.

Step Seven – Compare: This is the analytical part of the process. Again, this activity is usually the responsibility of the client, but given sufficient information the inventory service can also prepare a report. Some service-prepared reports can include sophisticated analysis of varying benefit to the museum. This step may also include coordination with the accounting department of invoices that have not or should not be paid before the end of the fiscal year.

Step Eight – Update: Update inventory numbers with the results of the verified count.

It's now up to you to determine if the benefits of having an outside service do your annual inventory is also cost beneficial.

Why You Probably Shouldn't
Open a Satellite Store

May all your dreams come true is an ancient Chinese curse that may have been originally placed on museums considering satellite stores. The decision to open a satellite store is not an easy one, and it shouldn't be, because the ramifications are enormous. So, rather than fantasizing about the dream, let's examine the accompanying curse and focus on when the time is not right for a satellite store.

It is not the right time if the original store is not adequately profitable. This is not so much a matter of the original store generating the income necessary to finance the expansion. It is an indication of the overall success of the store. Have the right core products been determined? Is there enough margin in the product mix? Is the store doing well on a broad range of comparative statistics (Average Sale, Dollars per Square Foot, Capture Rate, etc.) and not just those based on museum visitation?

It is not the right time to open a satellite store if you're not sure the new store can absorb additional costs. Can the store support a different mix of paid staff and volunteers – probably relying more on paid staff working more hours, and less on volunteers? How will the satellite store do after paying rent, full utilities, common area expenses, shared marketing costs and other expenses associated with mall, airport or strip center type commercial retail space?

You're not ready if you aren't sure you can afford the point-of-sale and inventory control systems necessary to keep track of and meld two operations. Significant design, build-out, fixturing, and increased inventory costs are another

consideration.

I often ask my museum clients who they think is their competition. The answers range from location, price and product mix comparisons, to some naive souls who think they have no competition at all. All retail stores everywhere are your competition – from sophisticated gift stores to Gap to Victoria's Secret to Barnes & Noble. The buying public is conditioned by these national chains to expect spectacular fixturing, effective lighting, great depth and breadth in inventory, and superior customer service. And all this costs lots of money! Sure, some people will buy from your store because it is the museum's satellite store, but you will need more than that to sustain you in the high cost and fiercely competitive atmosphere of most commercial retail centers.

It is also not the right time to open a satellite store if you're not sure you can accept some drastic changes in the way you do business. Are you ready to be open 363 days a year, 65 to 70 hours a week, with even more hours during major holiday periods or at airports? Even with drop shipments do you have the storage and transportation capacity to shuttle merchandise and sometimes personnel between stores? Are you organized enough and do you have the personnel necessary to manage, order, receive, inventory, monitor, staff and train personnel for multiple locations? Is your staff ready to move from the museum womb into the real world?

How about some softer issues? Is the museum administration mentally ready to accept short-term losses associated with expansion? Is management ready for the

probability of a smaller profit percentage, partially in exchange for increased exposure and membership sales? Do you know who your current customers/visitors are so you can evaluate if the new location is right for your store? Are you ready to compete directly against other stores and be criticized for doing so?

These are just a few of the many critical questions that need to be addressed before the decision is made to open a satellite store.

PERSONNEL

Best Practices for Staffing Structures

For most positions, except where prohibited by law, it is my experience that a well-vetted, trained and supervised volunteer in an environment where rules, expectations and consequences have been established and are enforced, can be just as effective as a paid staff person. Even in larger stores where the activity level can be more intense, the right volunteer, perhaps in a floor ambassador role that doesn't require getting involved in any aspect of executing transactions, can be a warm and effective member of the team resulting in incremental sales. Volunteers are part of some of the scenarios in this article. It is my view that museum stores which flatly reject the use of volunteers because of past experience have not established a well-designed retail volunteer program.

There will always be slow visitation days and there is very little a museum store that relies primarily on visitors can do about it. So that makes it doubly important the store maximize revenue on those days when it's busy. In my experience the best projection of how much store staff will be required is based on a historical record of transactions per salesperson hour worked, not revenue. Toward that goal, I encourage the following calculation be made to help determine how many people are required in a salespersons capacity to effectively service customers. A projection, **using numbers appropriate for your store**, might look like this:

 500 Visitation estimate
 x 25% Capture Rate
= 125 Transactions

÷ 6 Historical # of transactions/sales person, per hour
= 21 Hours of coverage required
÷ 8 Number of hours store is open
= 2.6 Sales staff

This estimate has to be adjusted for typical ebbs and flows during the day and it does not include staff people doing other things such as receiving and processing products in the back-of-house, schedule adjustments for lunches and breaks and the additional staffing needed if the store enjoys considerable destination foot-traffic. My suggestion is to at least try tracking both sales and transactions to see which provides the best guidance for determining sales staff coverage.

At the top of the retail organization is the manager. In most museums the title given to the manager will be dictated by the guidelines established by the personnel department to identify all museum staff positions. In general, *store* or *shop* is included in the title when the responsibilities are focused on the brick and mortar aspects of retailing. Museum Store Manager and Museum Shop Manager are examples. If the responsibilities include e-commerce, multiple locations, mail order and other roles the title may include the broader *retail* instead, such as Retail Manager.

Regardless of the position title, I have long advocated the following broad description of the position. The manager should have:

Full responsibility

The idea is to put all the eggs in one basket, then watch the basket carefully. I strongly prefer the risk that an individual may get off track on occasion (but if there are regular meetings with supervisors that shouldn't last long) compared to the often slow-moving and muddled objectives that result from a committee management structure. You know, a camel is a horse designed by a committee!

Proportionate authority to fulfil the responsibilities

This doesn't mean that some decisions should not be discussed with higher management before being executed, but the goal is to give the manager the empowerment to do the job.

Clear lines of supervision and reporting

The manager should be required to report to only one person or perhaps a small committee.

Minimal – and insulation from – interference and undisciplined collaboration

I forcefully make this pitch to every museum administrative group I address. This primarily means that the product selection process is clearly defined and the retail manager's supervisors will help protect the process from inappropriate influence from others in management, board members, trustees, etc. To be clear, the product selection process should provide for input from a broad array of sources, but only through established channels.

The concern about over-collaboration is focused on

the product development process. Too many times I have seen good ideas lose momentum and miss windows of opportunity because of undisciplined collaboration. There is no question that members of museum management, curators, the marketing department and others should be involved in the development of proprietary product, but the development process, just like the product selection process, should be clearly defined. Equally important, in return for the opportunity to provide input into the process, the participants should commit to a schedule that allows the process to advance in a timely manner. For example, if the marketing department needs two weeks to review product ideas, they agree in advance that the clock starts ticking when the proposal is delivered to them and they need to be ready with at least initial comments within two weeks. If curators need a month, that's fine, but their clock also starts upon delivery of the idea.

The most common management structures, in my experience, are listed below in the order of the frequency they are found, which also closely corresponds with cost. In this list, management includes managers, buyers and others whose primary responsibility is not selling.

- Paid management and paid sales staff.
- Paid management and mixed paid and volunteer sales staff.
- Paid management and volunteer sales staff.
- Volunteer management and volunteer plus paid *shoulder hours* sales staff (shoulder hours typically

include evenings and weekends).
- Volunteer management and volunteer sales staff.

There is no right or wrong staffing plan. A lot depends on the availability of both a volunteer pool and a budget for salaries. In general, it's probably true that the more paid staff the more professional the operation. But, in every instance I would choose to add a volunteer sales person on the floor instead of not having sufficient paid staff.

In terms of deciding who does what, I recommend a process that includes determining what each staff person likes to do and does well and what they don't like to do and/or don't do well. The manager gets first choice. The responsibilities taken on by the manger should be a balance of what they must do because of their position, what they like to do and what they do well. Nothing dictates that management must be the buyers. Given an Open-to-Buy and some guidance and supervision any staff person, for example, who has an eye for jewelry or knows books well can be the "buyer". On the other hand, if the manager doesn't do well with technology but has a great eye for merchandising and displays and is a keen price negotiator, nothing dictates that she/he has to maintain the POS at the expense of time devoted to what they do well. Much of the above is only applicable to stores large enough to have staffs of some size and is admittedly of only slight help to smaller stores where "management" is singular and staffing is very limited.

Implement a Dress Code

What issues should you consider when moving to a stricter dress code for employees and volunteers – possibly even a uniform – particularly for store employees who have some different responsibilities than the front-desk staff?

Let's start by establishing definitions – at least for use here. Uniform, as the name implies, typically describes a fairly strict definition of what must be worn. In general, a dress code sets parameters about proper attire allowing more flexibility than a uniform.

It's not unusual to have people on the visitor frontlines held to a stricter set of dress requirements than those working out of sight of the visitor/customer. Others, such as those working in foodservice, often have both laws and the preferences of the institution defining what they can and cannot wear.

I suggest you start by defining the purpose for a dress code. Often the impetus for a dress code is to make sure outlandish or inappropriate clothing and styles are precluded – or once there has been an incident, to make sure it doesn't happen again.

In fact, there are other more positive reasons for clothing uniformity. One of the most important is to create a sense of belonging for the staff. I do a fair amount of consulting with hospital gift shops. In that environment there is immense pride among the volunteers in wearing the volunteer or auxiliary member uniform. The uniform increases their sense of self worth, helps to identify other volunteers and brings them recognition as they go about their work.

Another reason for a dress code is to create instant identification for the visitor/customer. We all know that

most visitors have a near constant stream of questions from where are the restrooms to the location of a popular exhibit. It helps to relieve some of the frustration with getting answers in a timely manner by clearly identifying staff that may be able to help. Along the same line, parents and school group chaperones like to know the person who may be approaching their young children is associated with the museum. Also, the prominent presence of uniformly dressed persons effectively increases a sense of security and the perception of customer service without additional cost.

Another reason for a dress code is to enhance the museum experience beyond just identification and customer service. In addition to living history reenactment characters, staff in period dress throughout the museum sets an all-encompassing ambiance for the institution. By expanding the number of people dressed with a common theme you can be assured that everyone who comes in contact with the public fits the image of the museum. In the store we know the visitor values the experience and the product about equally, so a properly dressed person will enhance the shopping experience.

The Liberace Museum in Las Vegas does this very well. All floor personnel – those who are in constant contact with the visitor – must provide, at their own cost, black pants (trousers) and shoes, and black top or shirt. The museum provides docents, volunteers and other non-store floor staff with a sequined vest. The store staff is provided with a black and white piano key design vest. The impact of this dress code

is terrific. The staff is easily identified and subtly enhances the showbiz glitter and glamour of Liberace.

The process they went through to define this dress code may also be instructive. A committee was selected to represent the entire museum. The committee was made up of staff from each section – exhibits, store, admissions, foodservice and administration. They researched what was available from regular clothiers as well as uniform suppliers. Samples of uniforms were brought back to the entire staff for a discussion. Pros and cons were debated. The committee then had the responsibility to make the final decision.

I'd like to add one more component for consideration to be part of a dress code. Nametags (beyond security badges) can have a powerful effect on visitors and staff. The recommended design includes three components. First, the characteristics of the tag itself should reflect the museum's colors, or the shape of the building, or the image of a popular exhibit – something that ties it directly to the museum. Second, the first name or nickname of the staff person should be included. Third, the nametag should include a tag line something like this, *Member* or *Volunteer* or *On the museum staff since [the year]*. Whether the year is the current year or thirty years ago, that line helps to start an interpersonal connection with the visitor. The repeat visitor may respond with, "Oh, you've been here thirty years, do you remember when...?" Or, "I see you just joined us this year, welcome."

When a dress code is established, rules, expectations and consequences are needed to maintain consistency. Rules are

the core of the policy that cannot be violated and are not up for individual creative interpretation. Expectations are the parameters of the policy within which the staff person has some flexibility. If you believe a dress code policy benefits the museum then enforcement of that policy is also important, so there need to be consequences to violations. After one or two innocent violations the importance of the policy needs to be reiterated to the person. An exclamation point can be made by temporarily transferring them to a less visible position or, if violations persist, permanently transferring them. Only in very rare circumstances – such as for safety, health code or hygiene reasons – would dress code violations probably be grounds for dismissal.

Regardless of the dress code, an arrangement that requires the staff person to participate in the acquisition and/or maintenance of the apparel will result in a higher level of care. A small fund can be established, if necessary, to discretely assist those for whom the purchase of components of the dress code is a financial burden.

Finally, whatever uniform or dress code is adopted it should fit the image of the museum. While a primary colored T-shirt may be appropriate in a children's museum, most art museum settings would do best with a dress code that compliments the more sophisticated and probably higher-priced product selection. Also, it's fair to settle on a style of clothing that has the best chance of looking attractive on as many people as possible.

Hire for Attitude, Train for Skills

In both good and slow times, whether it's an ample or tight job market, this is a major area of concern. I'm not going to suggest what kind of people you should hire (except in a couple of instances) because so much of that decision depends on your customer base and the kind of store you have. But using the points in this chapter as a checklist will help you make sure you've given thought to all the major considerations.

Who are you looking for?
In general, hire for attitude and train for skills. The person with the capability and attitude to do the job can usually be taught the necessary skills. Of course, you may have special experience or accounting needs, but attitude, especially in sales positions, is important because people buy people not just product, and a positive attitude affects this relationship. In addition, a positive attitude has been correlated with dependability and honesty.

Start by writing down the general and specific characteristics of the ideal candidate. This description should include education level, special skills, relevant experience, work ethic, perhaps general interest in or knowledge of the mission of your museum, etc. Consider for this list the characteristics you are looking for if they are to grow with you. If horizontal growth is a potential, the ability to learn more about the breadth of what you do is an important requirement. If vertical growth is a possibility, then the ability to accept more responsibility becomes an important trait. Any list of characteristics must exclude race, color,

creed, national origin, religion, gender, physical appearance, residence location, age, disability, and sexual preference.

After you have completed your list, prioritize the most important attributes to make it easier to make a decision if you can't find or afford the perfect employee.

What do you want this person to do?

Write down specific tasks that need to get done. How many people are you looking for? How many hours/days/shifts need to be filled and when? Is an intern or a volunteer a possibility?

Next, write a job description. A job description will help you organize and present your requirements and start the building of a file of expectations, that has been shared with your employee, to which you can refer should there be issues in the future. Of course, the employee can do the same.

Where (#1) will this person work? On the sales floor, in the back room, buying, product development? Is telecommuting possible – such as for a bookkeeper? Is flextime a possibility?

Where (#2) will you find this person? I know, you and everyone else searches for employees through the newspaper and it can be expensive, but it often works. Here are some other possibilities:

- Business networks including recommendations from current staff.
- Local web sites dedicated to employment activities and links from other sites such as news organizations.

- Newsletters sent to museum members, clubs and residential areas from where you draw members and visitors. Flyers posted in neighborhoods with lots of people like your visitors.
- The gene pool. As long as the rule is established that one family member can't supervise another, this can be a terrific source of talent.
- Past employees. Keep in touch with good employees after they leave because the grass isn't always greener on the other side.
- Customer, member and visitor referrals.
- Sharing a good employee who works at another museum but needs more hours.
- Leads from vendors.

When do you need this person? Anticipating your needs and planning your hiring can result in a more successful search. When can you afford to start paying? The quicker you need an employee the less chance you'll have of finding the right one.

Why do you need this employee? I often believe museum stores are too conservative about staffing levels during the busiest of times. It's certainly not a pleasant experience to go through slow times. It is far worse, however, not to take full advantage of a busy period because you are inadequately staffed. In this circumstance not only have you lost sales, but many customers will perceive and remember this inadequate staffing as poor customer service.

So, you may want to think about why you need additional

employees in terms of return on investment (ROI). Will adequate (additional) help generate more revenue from the current level of customer activity? Are you too busy now resulting in lost sales and poor customer service? Does planned future visitation require additional staffing to maximize results? Or, can the current staff absorb the additional workload?

How are you going to pull this off? Do you have the money to pay for the "perfect" candidate? What's the ROI on a higher pay level for a superior employee? How close to the perfect candidate can you afford? If you can't afford the best employee refer to the priorities you established under the Who section to make sure you are focused on the most critical characteristics.

Require a job application. Ask for references. Check the information and the references on the application but don't put too much weight on positive references.

The interview

The goal of the interview is to get an inner view of the prospect. Focus not on what you can do for the prospect but what the prospect can do for you. A rigorous and candid interview process is essential to identify high and low performers, outline individuals' strengths and weaknesses, and to show that you care about whom you are hiring and you're not just interested in a warm body.

Pump up your strengths but don't sell the job. Listen for tips from the prospect about why they are looking for a job and

then focus on how you can meet their needs. Understand the difference between a perk (they can attend lectures for free) and meaningful work. To hire the best, interview using your best employees. Using these employees gives you a valued second opinion, subtlety showcases one of your strengths and makes your employee feel important.

Use established interview questions to make it easier to compare candidate to candidate. Whenever you can, conduct a second interview asking many of the same key questions again. Candidates often relax and let their guard down during a second interview and it's a good test of consistency.

In addition to specific questions, ask some open-ended, non-work related questions that encourage more subjective, personal responses.

Volunteers can be productive workers. For example, at a recent quarterly meeting of the Oregon Museums Association, an executive director related the story of a 75 year-old volunteer who entered over 9,000 items into the computer accessions program over a two year period. Now that's being productive!

Most museum store volunteers have been successful mothers/fathers, wives/husbands and/or business people earlier in their lives. Then, when they have more free time and decide to do some volunteer work, many are suddenly treated like invalids incapable of accepting responsibility or meeting expectations.

Expectations can include broad generalities about customer service and selling techniques, or specifics about cleaning. In general, I find volunteers will rise to reasonably high expectations. Let me give you three specific examples of expectations in areas closely associated with a well-run museum store.

First, zero tolerance for balancing the till at the end of the day. This expectation does not mean that the till must be balanced to the penny every day, but if it does not balance, a precise explanation of the reason for the imbalance should be expected.

Second, when more than one volunteer is working in the store at a time, require that only a limited number of them stay behind the cash-wrap, and others be specifically assigned to customer service, selling, and other responsibilities (including dusting) on the sales floor. Whether the store is

run with two or several volunteers, sales will increase and customer service will be improved if a volunteer is assigned to work in front of the cash-wrap.

Three, inspect what you expect and set a good example. If you have established expectations make sure, on a regular basis, those expectations are being met. If you don't inspect what you expect or set a good example yourself, the feeling that the expectations are not serious or important will quickly pervade the staff, nearly guaranteeing expectations will not be met in the future.

Empowering the volunteers and giving them some leeway as to how to get things done results in things actually getting done, the introduction of new and often better ways of doing things – and a more engaged and productive group of volunteers. Allowing interested volunteers to build displays is one example of empowering. Also, giving volunteers full information about the goals and progress of the store and an explanation of issues facing the store increases their involvement and can stimulate their interest in solutions.

It is also important that you train, retrain, and train the volunteers again. Training should be primarily focused on policies and procedures, customer service, selling and product knowledge.

And don't forget to praise each volunteer's effort – even just the fact that they showed up for their shift, and especially if they do something extra.

But what happens when things go – badly – wrong?

It is assumed that two steps will be taken before a volunteer

is fired. First, a sincere attempt should be made to help the volunteer do better. If that fails you should try to move the volunteer to another department within the museum where their skills could possibly be used more effectively.

If the first two steps fail, and it appears that firing the volunteer is the only solution, two more steps need to be taken before the volunteer is actually dismissed.

The first step in a successful firing of a volunteer is actually started when the volunteer is hired. Establishing well-defined expectations, as described above, sets the ground rules for their employment and establishes potential consequences. The second step is to document and discuss with the volunteer the violations of the expectations. The most unfair part of a firing is when a volunteer is caught off-guard and fired when they didn't even know they were not performing up to standards. When expectations are clearly stated, well understood, and adhered to on a consistent basis, it is easier for the volunteer to comprehend why they are being fired and helps to ensure that other volunteers will understand your action.

PRODUCT
SELECTION

How to Sell What Your Visitors Want to Buy

When buying for your store how do you strike a balance between your personal preferences and what will be successful? This is really about selling what museum visitors want to buy. The answer requires working within the parameters of the mission of the museum and the focus of the exhibits, and approaching the process in a professional, business-like manner.

When working toward this goal of focused product selection, there are a series of activities a buyer can go through. They are presented here in a checklist format and in rough order of importance.

First and foremost, the buyer must have a clear and precise understanding of the customer – what are the characteristics of the museum visitor? In addition, those museum stores which also attract non-museum visitors must know these customers' characteristics as well.

To coexist with Unrelated Business Income Tax (UBIT) rules and enhance the uniqueness of the store's product selection, the merchandise should reflect the mission of the museum and the focus of the exhibits. Some feel that if it sells it can be in the store. I disagree. While the UBIT-related aspects of this type of product selection can be dealt with, the uniqueness of the store is strongly impacted and results in a store similar to many others filled with generic collectibles, aromatherapy candles and potpourri.

If you are going to run your museum store like a business, potential product selections need to be evaluated for their sales volume, margin, turnover and space allocation impact.

It isn't enough to select the right products, they need to be present in quantities that maximize the profit potential of the store as a whole. In general, you want to make sure those products that produce the best sales, margin and turnover ratios are given an adequate amount of space in the store.

Another step toward maximizing the profitable selection of merchandise is to find out what the customer would like to buy. In general, we know what does and does not sell, but we spend very little time determining what could sell. Some of the things that can be done to determine what the customer wants to buy include:

- Scheduling the buyer(s) to work the sales floor on a regular basis so they spend time in direct contact with the customer, observing body language and engaging and overhearing conversations.
- Keeping a record of customer comments and questions – looking for preferences in those communications.
- Including the staff in product selection decisions. Remember, the products that often sell best are those the staff likes most.
- Debriefing the sales staff about their impressions of the product selection and the customer's reaction to them.
- Conducting exit interviews with those customers not making a purchase to determine why you didn't connect with them. Obviously there are many reasons why a visitor does not become a customer, but it is worthwhile to take the time to determine if any of

those reasons include product selection issues over which you have great control.

It needs to be noted at this point, however, that the final decision, regardless of the input from the customer, must be the buyer's and manager's. Rarely do customers have original ideas. For the most part customers do not have access to trade shows or manufacturer's representatives so their suggestions are usually based on what they have seen elsewhere.

Nearly all my consulting clients and those who have attended my seminars know I strongly favor the completion of a Product Distribution Matrix on a regular basis. The purpose of the matrix is to refocus the product selection so the customer-oriented characteristics of each product category are satisfied by the merchandise. The Matrix is fully explained in the chapter *Learn How to Project the Inventory You Need to Open a New Store*.

There are, however, strong reasons to cultivate one's own instincts. One of the best ways to do this is to create a product selection in one or two categories in the store that, because of the depth, breadth or unusualness of the selection, becomes a category for which you are known. Often this will create the want in what the customer wants to buy, because they don't believe they will see such a complete selection of products anywhere else. This is not only a powerful selling tool but also – because it creates a clear image of the store that the customer can more easily remember – encourages word-of-mouth advertising.

Finally, there is a series of less intensive exercises that can help round-out a customer-oriented product selection:

- Walk trade shows with the purpose of absorbing trends, colors and popular products and not, for the moment, buying.
- Read trend and demographic magazines.
- Converse with reps.
- Scout the commercial and museum store competition.
- Review catalogs looking for mission-related products that are repeated from issue to issue.

One last part of this entire process is to keep a good record of results including, at least:

- Sales by category and subcategory.
- Dollars per square foot by product category.
- Average transaction.
- Capture rate – the percentage of visitors making a purchase.

ABOVE AND BELOW: Carrying a design vision from the exterior to the interior.
Lan Su Chinese Garden, Portland, Oregon

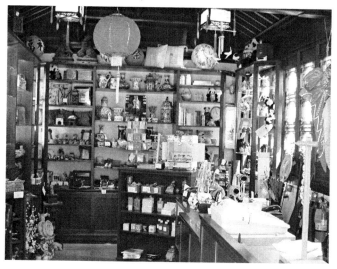

Make Jewelry Your Must-Have Product

Jewelry, in all museum-type stores – but especially art museums and botanical institutions – continues to be a brisk seller. Couple that with some of the highest margins of any product category, smaller space requirements and the appeal to women – the majority of visitors in most institutions – and jewelry becomes a must-have product category.

As with nearly all product categories, the most important factors for success include product selection, product knowledge, merchandising and customer service and selling.

Product selection

Make sure to differentiate your selection from other stores by only selling pieces with mission-related motifs. The real difficulty will not be finding jewelry with appropriate motifs but choosing from all the jewelry available. This can include reproductions for history museums and historic sites and homes, botanical themes for gardens and arboreta and, for art museums, an almost limitless selection of themes.

Within your selection you can carry inexpensive jewelry merchandised on counter spinner racks and much higher-end pieces merchandised on props in a jewelry case. As with all other product categories you must sell jewelry that appeals to a broad spectrum of your visitor's selection and price preferences.

Product knowledge

Entire books are written on jewelry, but there are some key

factors your staff should know about your selection. Foremost among them is how the jewelry relates to the institution's mission and exhibits. Is the jewelry a reproduction? If yes, of what piece, from what time period or where is it displayed in the museum? If the piece is a contemporary original who's the artist? What materials are included?

It's also important that staff know something about the points of quality of your better jewelry. Some key factors of the materials most often found in museum stores include:

- Pure gold is 24 karat, but since it is such a soft metal it is rarely used in this form so it is typically mixed with other metals to improve hardness and durability. Unless the gold is pure, the karat, the proportion of gold mixed with other metals, should be stated. For example, 14 karat gold is 14 parts gold for every 10 parts of other metals. The description of a quality gold piece should also include some indication of the entity that will stand behind the karat designation. It's also important to identify if a piece is gold plated, filled, flashed or washed.

- Silver and sterling silver refer to a product that contains at least 92.5% silver. Silver can also be marked as parts per thousand of silver. According to U.S. law, silver must bear the name or a U.S. registered trademark of the company or person that will stand behind the mark.

- Platinum is typically more expensive than gold and is marked as a percentage of pure platinum parts per

thousand of platinum group metals. Typically 950 platinum can be marked simply as platinum.

- Natural gemstones are those found in nature. They should be distinguished from laboratory-created or laboratory-grown stones even though they have similar chemical, visual and physical properties. Imitation stones should be clearly distinguished from both natural and laboratory stones. Many gemstones are treated to enhance appearance or durability and the nature of the treatment should be conveyed to the customer.
- The characteristics of pearls should be known and explained to the customer. This includes natural (very rare), cultured (where an irritant is introduced into the shell of the mollusk) or imitation pearls. As with gemstones, any treatment of the pearls to enhance the appearance should be disclosed.

Clearly, jewelry includes many other materials both natural and manufactured. Many institutions have had great success selling jewelry that includes natural materials from the institution. Wood from blown down trees, scraps of metal and stone from construction, leaves and twigs from the property have all been successfully integrated into original jewelry designs.

It's also important to let the customer know about the type of clasp, materials used for stringing, etc.

It is considered great customer service if you advise how

to clean and care for jewelry purchases.

Merchandising

The selection is clearly the most important aspect of successful jewelry sales but you must also make sure the jewelry is merchandised well. The key elements of attractively merchandised jewelry include glass cases with interior lighting and props on which to display the jewelry to heighten visual interest. In general, the higher the quality of jewelry the less dense the merchandising should be. In this circumstance, less is more.

One downside of jewelry is that you'll have to provide enhanced customer service by taking the jewelry out of the case so customers can get a closer look and try it on. As a result, when possible in smaller stores, it is best to integrate the jewelry case into the cash-wrap in a location that is highly visible to the customer but also one where other customers won't constantly jostle the jewelry customer. Jewelry customers consider a purchase longer than any other product category so it's important they be able to do that without being interrupted by other customers.

There is a near constant debate about showing or hiding the price tag for jewelry. Many feel price tags should be visible so customers can pre-qualify themselves and avoid embarrassment if the price is too high. Others, and I'm one of them, feel price tags should be hidden for two reasons. First, we don't want the customers to pre-qualify themselves because that reduces the opportunity to find out what the

price is by taking the piece out of the case, thus bringing the tactile experience one step closer to the customer. Also, hiding the price tag eliminates the distracting visual clutter of having a tag showing for each piece of jewelry.

Customer service and selling

An ideal incentive for purchase is to have the sales staff, especially if some staff is assigned to the jewelry counter, wear the jewelry – especially necklaces where there is less chance of damage to the pieces. Appropriately dressed staff wearing jewelry quickly give the customer a visual idea of how it will look on them.

Also, don't forget:

· Quickly bring out jewelry of interest from the case.
· Place the jewelry on a pad to protect the pieces and enhance the perception of quality.
· Have a hand or small standing mirror available so customers can see how the jewelry looks on them.

Attend Trade Shows to Build a Distinctive Product Range

What percentage of a museum store's operating budget should be allocated to trade shows? And how many shows should a buyer attend?

I have never seen an industry standard for this expense, and one probably can't be clearly established since there is such a wide variety of museum store operations. It is clear to me, however, that attending as many shows as your product breadth requires and your financial constraints allow is critical to enhancing the profitability of your store.

One of the strongest components of product selection that allows you to expand your profit margin is distinctiveness. If your product selection includes merchandise that is not available at other museum and commercial stores in your area you can, and are entitled to, increase the retail price to the upper limit of what the market will bear. This increased retail price is appropriate to compensate you for the time and effort expended finding unusual merchandise. The pricing of this merchandise is important because it helps to counterbalance other lower margin merchandise in your store.

At a basic level there are five categories of shows that should be evaluated when preparing your trade show budget:

- *Member's Market and Expo* at the Museum Store Association annual meeting. These are the most concentrated markets of museum-type and museum-quality products available during the year.
- Specialty market trade shows focused on, for example, books, toys and paper and stationery. Also included in this category are annual meetings for your type of

museum that include retail product components.

- Your region's gift show. Attending these shows supports local manufacturers' representatives, makes sure that you at least see the same products that other museums and commercial stores will be choosing from and is your least expensive trade show budget component.
- Additional gift shows outside your region to further expand your horizons.
- Local craft fairs. Don't miss this inexpensive and fun alternative. Not only will you find unusual, one-of-a-kind products, but you may have the opportunity to establish an exclusive relationship with a craftsperson that will enhance the uniqueness of your product selection.

I am not suggesting that all museum store buyers attend multiple shows regardless of the size of the retail operation. There is a direct correlation, however, between the amount of effort you put into looking for merchandise and the unusualness and diversity of your product selection. If you primarily rely on representative visits and catalogs for your product selection you will have a more difficult time making a memorable, strong, mission-related statement.

One last note. When choosing the shows to attend, evaluate some ancillary factors such as museum stores in the area that you can visit and the educational seminars presented in conjunction with the shows. I am a strong advocate of

borrowing product selection, merchandising and display ideas from other museum stores. Equally important is being introduced to strategies that work in other retail sectors and adapting them to your store for a fresh look.

Making Sure Your Revenue Will be What You Expect

Your New Fiscal Year checklist should include revenue and margins – the two components that most directly impact the financial success of your store – and some merchandising, display and customer service factors that affect customer spending. Although such a list is practically endless, a common thread is the low- to no-cost required to put these changes into effect.

Revenue

Revenue is mostly the combination of expenditures by museum visitors; online, catalog and wholesale sales; and, where the store has become a destination store or there is a location away from the museum, non-visitor shoppers. The level of sophistication of those to whom you report and the priorities of your institution may affect what's on your list of things to do, but let's assume everyone shares the same goals and that we're focused on your bricks and mortar presence. Also, let's assume some revenue projections have been established.

The first step to making sure revenue will be what you expect is to verify visitation expectations.

Has the exhibit schedule changed? Have special exhibits or events that impact the store changed in number, length or location? Will you be open the same number of hours during special exhibits and events? How do you and others in the museum expect updated economic information to affect visitation and sales per visitor?

Because as a store manager you have relatively little impact

on visitation, make sure you are at least maintaining Store Revenue per Visitor calculations so the results of your efforts are linked to visitation.

Expenses

The biggest expense between revenue and profit is cost of goods and that's where you may want to concentrate your review. What are some things you can do to lower the cost of goods and increase margins?

First and foremost on the list, are you consistently calculating and following an Open-to-Buy (OTB)?

While staying within OTB parameters, can you combine or increase the size of orders to secure free freight, marketing dollars or volume discounts?

Are you sure proprietary product development is on sound financial footings regarding the cost of production and the units required to make the retail (or wholesale) cost attractive to customers?

Are you taking advantage of all available free marketing such as listings in museum and local newspaper, online and printed publications?

Merchandising, display and customer service

Retail is detail. We never know for sure which detail will impact which customer – positively or negatively – but the following are sure to have an effect on revenue and should be on your checklist:

- Is your store clean?

- Is your store over-merchandised and cluttered?
- Are there fixtures with chipped laminate or scratched paint or woodwork?
- Are the carpets stained or worn?
- Are lights fully lit?
- Does the lighting leave dark areas that can be brightened?
- Is the horizontal glass on the top of your jewelry cases relatively free of scratches and view-blocking display pieces such as small spinner racks?
- Are books merchandised by category with good signage?
- Have you conducted refresher customer service and sales training recently?
- Do your freestanding fixtures generally increase in height toward the back and sides of the space so customers can see the entire store when they enter?
- Is the merchandising and display interesting enough to get a customer to slow down and linger?
- Does the merchandising and display stimulate add-on sales?

There are Two Transactions for Every Gift Certificate You Sell

In this time of electronic gift cards there is still a place for the tactile presentation of gift certificates. Are you considering offering gift certificates at your museum store, but not sure of the best way to set up a system for selling, tracking, protecting against fraud and accepting them? Or even if it's worth the trouble to sell them at all?

Let me answer the last question first with an emphatic, yes. Gift certificates should be considered another product to be marketed and merchandised with benefits for both the customer and the store.

For the customer, gift certificates are an excellent answer for people who are not sure about a purchase or are under time constraints. Some customers see the benefits to the recipient as getting them what they really want. Overall, it is estimated that 40% of people give at least one gift certificate during major holiday seasons.

For the store it can save a sale by helping an indecisive customer make a decision or make up for a temporary inventory deficiency. Other benefits include no immediate cost of goods, no inventory and little merchandising space. Gift certificates also significantly reduce the cost of returns and often result in a purchase in excess of the face value. And from a cynical standpoint, many certificates are never redeemed, providing pure profit for the store. In many retail settings, gift certificates represent the highest margin sales.

Remember, too, there are two transactions for every gift certificate, the purchase and the redemption, and both can

result in satisfied customers. It's also not unusual for one or both customers to be new to the store and at both transactions there is an opportunity for incremental sales. When purchased the customer may buy other products and at redemption, as mentioned previously, the recipient often spends more than the face value of the certificate. (Remember to add the names of new purchasers or recipients to your customer database.)

There are vendors who provide pre-printed gift certificates and gift certificate programs that provide the certificate and nearly foolproof procedures and records. Some programs even include duplicate certificates. I would urge you, however, to develop your own program taking the following points into consideration:

- Print the certificates on good quality stock that reflects the image of your store and museum.
- Incorporate the store or museum logo and color scheme.
- Spend money to get the certificates pre-numbered.
- Package the certificate well using an attractive envelope or a gift box.

The certificate should include space for:

- The recipient's name. Some suggest additional information about the recipient such as address or telephone number to help reduce theft. Personally, I believe it takes too long to complete additional information, feels intrusive and institutionalizes the look of the certificate.

- Purchaser's name.
- Amount, written and numeric like on a check.
- Date of sale.
- Expiration date. (Put a generous time limit on the redemption, say a year or so from the date of issue. At the same time, if someone presents a certificate for redemption after that date you should gracefully accept it as long as the records to verify its authenticity are still available.)
- Initials of the salesperson.
- Statement about not being redeemable for cash. Do not give cash for the certificate and if it's only partially used don't feel obligated to turn the balance into cash until the remaining balance is small enough to not warrant additional administrative handling. Note the declining balance of the certificate on the front of the certificate. The entry should note the remaining balance and the initials of the salesperson making the adjustment.

By making the design unique it makes the certificate more difficult to reproduce and helps reduce fraud. Good record keeping is also necessary to reduce fraud. Keep a record of each certificate sold and redeemed in a log. The log should include the following information:

- Certificate number.
- Date sold.
- Amount.

- Recipient.
- Purchaser.
- Method of payment.
- Date redeemed.
- Comments (if any).

When sold, process the sale using a special code or PLU/SKU number. When redeemed use another code or PLU/SKU for the transaction. The certificate accounts for the difference between sales and actual revenue when redeemed. Outstanding certificates are a liability and redeemed certificates become an asset. It is important to keep track of the two totals so you know the value of outstanding certificates – your potential gift certificate liability.

You want to avoid doing what one of our clients used to do. In order to limit the liability of outstanding certificates, they used to put the cash equivalent in a box. When a certificate was redeemed the cash was withdrawn from the box and put into the cash drawer. These procedures certainly limit the outstanding liability but create a monstrous administrative problem and the real potential of theft.

To prove the value of a gift certificate program, for every redemption note if it is made by a new customer and the amount of the total sale associated with the redemption. I predict that a significant percentage of the redemptions will be made by customers who have not been in the store previously and most will result in sales beyond the face value of the certificate.

I believe so strongly in the value of gift certificates, I suggest you prepare a simple marketing plan that includes posting signage about the availability of gift certificates at the checkout counter and near those product departments where decision making, because of the depth or breadth of your selection, is the most difficult.

Incorporate certificates into gift-basket and corporate gift-giving programs and use them as donations. When used in this way, the cost of the certificate should be viewed as a marketing expense. The advantages to the store are many:

- First, let's contrast it with donating a product. When giving a product you're never sure in what condition the product will be when it reaches the ultimate recipient. Will it still represent your store well?
- The recipient of a gift certificate must come into the store to redeem it. When they do, statistics show that most customers spend more than the value of the certificate.
- Don't forget, many certificates are not redeemed so you get the publicity and credit for helping at no cost.

When *Green* becomes the topic in museum store retail conversations it seems to mean different and changing things to different people. Green can apply to several areas, but first, or eventually, the conversation usually turns to products, so, through some examples and comments, let's explore product trends first.

Some retail Green trends include:

- Favoring products that require limited or easily recyclable packaging. Keeping in mind, however, even some Green products must be carefully packaged to prevent damage – and a different kind of waste.
- Products made of or including reclaimed, bio-degradable and renewable materials.
- Offering fewer products made of leather.
- Print-on-demand, and often drop shipping, for books and some two-dimensional products versus keeping stock on hand.
- Apparel made from natural or organic fibers.
- The selling and/or use of reusable shopping and tote bags.
- Focus on reusable products like mugs, as an example, which are generally environmentally friendly.
- Durability.

In my hometown and state, Portland, Oregon, there is a strong focus on eating locally-grown produce and only reluctantly expanding outward to regional, national and international sources. In your store are as many soft, hard and

food products as possible locally-made to lower the impact of transportation? Are tissue paper, wrapping and packing materials environmentally friendly, recycled, reusable?

Ancillary to the topic of Green are concerns about countries of origin, fair trade and organic certification.

If you make Green part of your mission, you may be able to include books about the subject and, for example, cleaning supplies as part of your product selection. Some history museums could go back to old formulations that may include baking powder and vinegar that are far less toxic.

Retail conversations about Green less frequently include related topics such as operations and fixture materials, so let's take a quick look at these aspects.

Green fixture concerns include:

- Displays and fixtures built with salvaged materials or from some of the fastest growing commercial wood such as bamboo and mango using certified sustainable harvesting programs.
- General durability.
- Types of glues and laminates used in the fabrication.

A part of many fixtures is lighting. The focus is on the kind of bulbs, such as compact fluorescent (CFL), which by the way, need to be disposed of properly because of their mercury content; LED (Light Emitting Diodes); fixtures (even some bulb sockets are made from recycled materials), and habits.

Store design may be able to effectively, and safely from the product's standpoint, use natural light. Many studies have

documented increased sales and generally happier customers in retail environments that include natural light.

Operations

- Recycle and compact shipping and other waste.
- Recycle batteries for those who buy new batteries in your store.
- Don't print emails.
- Print on both sides of a page.
- Place orders via the internet rather than mailing or faxing.
- Convert documents to PDF files and store on a computer.
- Carefully choose cleaning products used on glass and floors.
- Schedule travel and errands to minimize unnecessary driving.
- Recycle office paper, purchase recycled office paper and supplies, use glasses and mugs instead of disposable cups.
- If your museum is open when the store is closed, say for an evening event, show off the store by leaving some lights on using a circuit with a timer that turns them off later in the evening.
- Turn off those electronics that you can overnight – especially on Fridays.
- Because many electronic devices use power even when off, use power strips to disconnect those not in use.

- Because of limited budgets, museum store managers already do this well, but try to find new uses for old things.

Marketing and merchandising

When a store is responsive to Green issues it is appropriate to publicize this through public relations and marketing. This can be done not only to promote products and enhance your image, but, since most consumers want to do their part, also to encourage by your example.

If your building is in compliance with any level (Certified, Silver, Gold, Platinum) of LEED (Leadership in Energy and Environmental Design) certification, the recognized standard for measuring building sustainability, let your customers know. As an aside, while the general interest in Green by women may be greater, there is a high degree of interest in the technical aspects of a LEED building among men, which could be a bridge to building a connection with male customers.

Some marketing ideas that incorporate continuing education, one of the critical goals of museum store product selection, include:

- Identifying Green products with special signage.
- Especially in the beginning when you may have few products, for greater impact merchandise Green products from a broad range of categories together. Signage may state: *In an effort to be environmentally attuned, we are moving toward including as many Green products as possible in our selection. The products in this*

section/on this shelf are the beginning of this effort. Maybe you can paint this section green.

- Use positive and Green-associated words and phrases like: Reduce. Reuse. Organic. Local. Natural. Fresh. Non-toxic. Earth friendly. Good for the environment.
- Enhance the use of websites and emails to generate publicity.
- Educate customers on some core elements such as end-of-life options (a catchy phrase focused on what impact the product and packaging will have on the environment when the product is no longer being used); embodied energy (quantity of energy required to manufacture and supply to the point of use); right-sizing, etc.
- Inform customers, for example, that since conventional cotton production uses a disproportionate percentage of the world's chemical pesticides and fertilizers but only occupies 3% of farmland, your products are made from organic cotton, 100% chemically untreated cotton, or hemp.

Be aware that as your store becomes more Green there may be growing pressure to become greener which may then reflect negatively on those products that are not yet Green.

I'm a big believer in the power of the incremental sale to increase profitability. A part of incremental sales is taking what we are given in terms of visitors and squeezing additional, incremental, purchases out of them.

Generating more sales from male visitors is a perfect example of this philosophy. The men are there already, as the primary museum visitor or accompanying spouses, children, other family members and friends. Taking the time to stimulate their interest can simply lead to additional sales.

The first step to increasing sales to male customers is to believe there is a male market. Men are not impossible to buy for, sell to, or recommend products for, but they can be a challenge. Once you and your staff believe men will buy, there will be a male market for your store.

There are too many different kinds of museum stores and male customers to establish a foolproof way to increase sales from this segment of your visitors. So, I'd like to approach the subject through three checklists that will lead you to develop a program that works best for your store and visitor.

First, let's list a few widely accepted generalities.

- While women make approximately 70% of all retail purchases, men have access to a sizeable reserve of disposable income.
- Men move more rapidly, spend less time, ask fewer questions and are harder to get to focus.
- Men will make up their minds quickly.
- Once they have made up their minds, men are less concerned about price. A range of price points,

however, should be available.

- After they feel comfortable with a store, men are very loyal customers. This loyalty can be a huge asset to museum stores that draw from the general buying public in addition to museum visitors.

So, what works?

- Men are attracted to darker, richer colors, especially browns and earth tones, regardless of which colors are trendy at the moment. This applies to both merchandise and fixtures.
- Leather, suede and wood grains are very popular.
- Texture has an appeal equal to graphics.
- Sports, financial, electronic, gadget, nostalgia and transportation motifs. The most popular U.S. sports include baseball, high school sports, football, golf and fishing. Hockey is on the list in the Northeast and Midwest United States.
- Snack and prepared food items.
- Function over decoration.
- Helpful signage, especially that which distinguishes male from female products, such as for apparel. A national gym company saw sales of male apparel double after it used signage to clearly distinguish male from female merchandise. In addition, men, not unlike many women, don't want to ask questions and call attention to themselves.
- Humor in product, merchandising and displays.

- Cross-merchandising generic gift items with male oriented merchandise. Rather than expecting the male customer to seek out a wide variety of product categories, bring examples of other categories to them.
- Creating a nook, corner, or at least a mini-display toward the front of the store devoted to male oriented products. Women will readily walk through a male section to get to their areas of interest but, in general, men are far less likely to walk the entire store in search of something of interest.
- Integrate audio and visual elements into your displays. Men can fairly easily be manipulated to stop, look and listen.
- Diversify your sales staff. When buying for women, men prefer female salespersons. When buying for themselves, men prefer men.
- Are there exhibits in the museum that are particularly popular with men? If so, recall those images in your merchandise displays.
- Facilitate gift giving. Make gift boxes, wrapping service, greeting and enclosure cards obvious.
- Emphasize your no-hassle return policy.
- Train your staff to greet the male customer and then leave them alone.
- Merchandise gift certificates with male oriented products.
- Prior experience with a product has a strong influence

on purchasing. Brand names and images that evoke familiarity will reduce buying resistance.

There is another aspect to having men in the store that should be given consideration. Men influence what women buy, and perhaps most importantly in this context, how long they spend in the store. An impatient male, perhaps negatively influenced by the factors below, will shorten the buying window. So, while marketing toward men will increase their purchases, keeping their interest will also allow other members of their party to linger longer and buy more.

What doesn't work? Many of the factors listed below also influence the buying patterns of women, but may more heavily affect a male:

- A store that is too warm. Men will simply leave a store that is too warm much more quickly – taking the rest of their party with them – than a store that is too cool.
- Heavy fragrance. If your product mix includes aromatherapy candles or potpourri (by the way, are you sure these products are mission-related?) merchandise them toward the back of the store so the HVAC (heating, ventilation and air-conditioning) has a chance to dissipate the fragrance.
- Crowds and long lines.
- Poor signage, especially missing price tags and apparel related information, both of which require the asking of questions.

- Clutter.
- Overly talkative and/or under-informed salespersons.
- Loud music.

One last point. Just as men don't know what to buy for women, many women don't know what to buy for men. By focusing the merchandising of a part of your store toward men you will also be facilitating purchases for men by women.

Stock Seasonal Products but Stay True to Your Mission

How can you buy product that reflects holidays and seasons, but stays true to the mission of your institution?

Too often products with a strong holiday feel – but totally unrelated to the mission or exhibits of the museum – are brought in to the overall detriment of the store. I believe the strongest characteristic of most successful museum stores is a unique and focused product selection. Anything that is done to dilute this image, making the store more a gift shop than a museum store, and possibly confusing or disillusioning the visitor, does not benefit the store in the long run. In the short run it may generate more income, but it is done at the risk of raising UBIT concerns and affecting the impression the store leaves on the visitor. It may be helpful to remember that even with longtime customers, the last visit to the store is the strongest segment of the overall and lasting impression of the store. The store's image also has an effect on the perception of the museum as a whole. A Canadian colleague best stated a guiding principle of this interrelationship several years ago. She said, "If a visitor goes into the museum store first and then is not surprised by anything they see in the museum, the store is doing a good job of product selection." That may be the golden rule of museum store product selection.

So, what can be done to give the store a holiday feel while staying true to the mission and exhibits of the museum? Let's start with some ideas that are not directly related to product. The following comments are generic in nature and applicable to all holidays.

When there is a holiday theme in the store the customer

will perceive your usual, mission-related products in a different light. Think back to presents you have given and received during a holiday. What percentage of them actually had a holiday theme? Usually, very few. In most instances regular products are wrapped or presented in a manner evoking a specific holiday feeling. Also, don't forget about other occasions occurring around the holiday. For example, during the two month year-end holiday season, 16% of the population has a birthday and there are countless other special moments.

When decorating the store, remember the product should remain the star. You want the decorations to set the mood of the holiday, but it should not distract the customer. You don't want customers walking through the store admiring the decorations while ignoring many of your products.

An alternative to decorating the whole store is to create individual displays and vignettes with holiday themes while leaving the overall ambiance of the store unchanged. This can include gift-wrapped boxes and signage placed around the store to give a hint of color and celebration, and the subliminal suggestion of gift-giving. This method of holiday merchandising also allows you to include multiple holiday themes at the same time. This may be particularly helpful during the year-end period when the Christmas, Hanukkah and Kwanzaa and New Year holidays share the same general time period. This method also allows you to respect cultural differences between the holidays. For example, while Christmas and Hanukkah are often celebrated with

extravagant gift-giving, Kwanzaa is usually celebrated with an exchange of more symbolic gifts.

Holidays are also a great time to plan events such as book signings, demonstrations, how-to workshops and readings. Each of these events can have a holiday focus such as reading about Christmas during the Lewis and Clark Expedition, or demonstrations of how foreign countries decorate for New Year, or making Valentine cards with themes from around the world or days gone by. Each of these events may use product from your regular stock in the context of the holiday.

During a holiday period you can bring in different colors of your regular mission-related products. Red may not be your favorite rendition of a product, but at Valentine's Day or at Christmas it adds to the holiday spirit while staying true to the mission-related focus of the store. The same can be true for art kits for children. For example, an art or children's museum may modify its selection of starter art kits to reflect a holiday theme.

The quantity of product bought can also affect how you balance between a holiday mood and the mission of the museum. Bring in only as much strongly themed product as you are sure you can sell. The remaining inventory can be perceived as holiday through association with themed products and the holiday display and merchandising in the store.

The location of holiday-related product and decoration is also important. Halloween-related merchandise, for example, can be introduced toward the back of your store in early October and move or expand into the front of the store

as the holiday approaches. Let me be clear about one point. I am not advising that the introduction of holiday related product is appropriate for all museums and for all holidays. I am suggesting, however, as museum stores compete for discretionary spending during holiday periods they can use the spirit of the holiday through decoration, product selection and events to increase spending and can do so without violating some of the principles of museum store retailing.

There is no question that finding holiday-themed, mission-related product does require more looking. Often, however, vendors can help. Ask your vendors for their ideas about what can be done to give a mission-related product a holiday look. They may have some packaging, color or other options for you to consider.

Sometimes, just the simple changing of a ribbon or other detail can make all the difference. A zoo that sells plush bears can add or change the color of the ribbon around a bear's neck to reflect and subtly suggest an association with a holiday.

Blend Your Store's Mission with Contemporary Trends

Your product selection must stay true to the mission of the museum, but you'd like to get on some of the popular product bandwagons to help improve sales. How can you become a bit more trendy and still stay true to your mission?

Maybe we should start by looking at the definition of trend from a technical and practical standpoint. Technically, a fad is something that gains extraordinary popularity for a relatively short period of time, say six months to two years. Trends last five to twelve years followed by traditions which kick in at about twenty-five years.

From a practical standpoint it's important to understand that trends are much less about specific products and more about lifestyle statements and choices. Product choices made within trends are not ends unto themselves, but a means to the end. It is less about an item and more about an emotion or feeling evoked by those items. For example, it isn't that the *outdoors-in* trend is about gardens or plants as much as it is an attempt to extend the beauty and serenity associated with the outdoors into the home where it typically doesn't exist and especially not during the winter months or in urban centers.

To become a bit trendier you need to know how to spot a trend. In general, if you see a topic discussed in three or more divergent publications you're probably looking at an established trend or one that's in the making. So, if *Time, Museum Store, Nursery Retailer* and *Gifts and Decorative Accessories* have articles about products that appeal to the Hispanic market (growing at four times the rate of the U.S.

population in general) you have the insight on a trend. From another retailing perspective, if you walk a gift show and observe similar themes displayed in paper product, apparel and toy booths, it's another indicator of a trend.

So, lets say you have identified a trend, how do you incorporate it into your store, stay within the mission of the institution and increase sales? First, understand that to do this successfully you have to draw attention to the trend and put the products in the context of the mission. You can't always rely on your visitors/customers to ferret out trendy products within your merchandise selection.

Most customers, especially tourists, need you to lead them to the purchase of more products. Some of the products that build these incremental sales can be trendy, subtly appealing to what they have seen in retail and other venues.

If you are an historic site with a heritage garden, a direct link to your mission may be heritage seed packages, but they can be augmented with other products that reflect the current outdoors-in trend and make a lifestyle statement. You may want to display and merchandise the seeds with:

- Vases based on historic themes.
- Table linens with pictures of relevant plants and flowers.
- Small tools for container gardening.
- Activity kits based on plants and flowers.
- Other garden accessories with historic or period themes, including floor and wall containers, pedestals or figurines – all currently trendy in the garden world.

A customer looking at this display may think how great it would be to grow historic plants in historic-themed pots and display them in historically-based containers that fit into their home decorating theme and bring the outdoors, in.

Maybe another, more subtle, example will further illustrate how this can be done. Let's assume angels are a continuing trend. An historic house that features Christmas ornaments could put the emphasis on ornaments that include angels. Botanic gardens and arboreta could highlight garden and lawn accoutrements featuring angel designs. In both examples nothing is screaming *buy me I'm trendy*, but these product selection, merchandising and display highlights slyly appeal to customers because it fits into what they have already seen in ads, *Target* and design magazines.

Just adjusting the emphasis of your general product selection can also tap into trends. Do you have established product lines that can be tweaked to emphasize pet motifs or trendy colors? The word *Connect* may be the clearest description of a substantial overall retail trend that has people reaching out to others. Toward that end, how's your selection of stationery, albums, journals and archival supplies?

Let's switch gears to another way to introduce trends into the museum store and increase revenue. Not all connections to trends have to be through specific trendy products. If you are in an area of the country that is experiencing the Hispanic population increases mentioned previously, are you tapping into that market through your choice of colors and designs?

Simplicity is another emerging trend with, for example,

increasing subscriptions to *Real Simple, The magazine for a simpler life, home, body and soul.* Television shows like *Mission: Organization* and *Clean Sweep* fit into the same trend. The new emphasis is on connecting with one another rather than buying collectibles (dustables) and clutter. Boxes and baskets fit this trend by combining function and decorative objects. Does your store do anything to connect to the strong *retailtainment* trend, or is it just a flat merchandising of product? How do you fit into the move towards value and natural materials and away from cheap?

So, being trendy has to do with a combination of specific products, ambiance and merchandising all working to send a message to the customer that the museum store is a reflection of the institution's mission set in today's world.

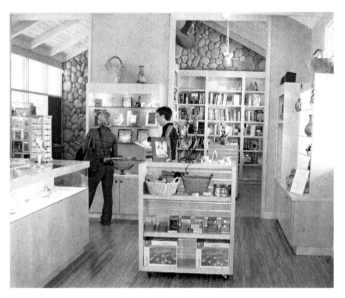

Bringing the outdoors inside.
Santa Barbara Botanic Garden, Santa Barbara, California.

Appendix:
Useful Forms

To make sure all readers can complete the recommended forms they are designed to be used with pencil and paper. However, depending on the level of competence and comfort with technology, readers are encouraged to computerize the forms to decrease the time requirement and increase accuracy.

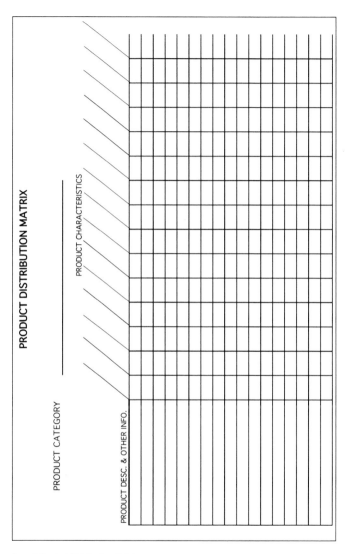

Form 1: Product Distribution Matrix

Product Distribution Matrix Instructions

1. At the top of the page identify the product category or sub-category.

2. Along the top horizontal axis, list the key product characteristics the products in this category should satisfy. For example, if the product category is Books, some key characteristics may include:

- A couple of slots for the type of book
- Hard Cover
- Soft Cover

Reading level may be broken down into three levels:

- Beginning Reader
- Intermediate Reader
- Advanced Reader

Possible retail price levels:

- Priced below $10
- Priced between $10 and $25
- Priced over $25

Topics:

- Women's History
- Black History
- Native American
- Lewis & Clark

… and so on.

The key characteristics are, of course, different for each product category, vary from institution to institution and are yours to determine.

3. Along the left, vertical axis, list all the products (or groups of very similar products) under consideration for this category or sub-category and any additional information you need for reference. For example, if you are preparing the matrix before buying you may want to note the vendor.

4. For every product listed on the vertical axis, put an "X" in the column under each characteristic this product satisfies. This can be done with pencil on paper or as a computer document. As the matrix is completed it will become apparent where there are holes or excesses in the product selection. Purchases can then be adjusted to assure all characteristics are represented in balance you prefer.

Form 2: Retail Price Distribution Matrix

Retail Price Distribution Matrix Instructions

1. Use the provided or any other similar form. The size of the form depends on the divisions needed to reflect the distribution of retail prices in some detail. For the best insight, complete a form for each product department/category and then amalgamate for the store as a whole. This can also be done on a computer.

2. Divide the bottom horizontal axis into equal retail price categories from the least expensive (left) to the most expensive (right). In general, \$2.00 to \$3.00 increments are best.

3. Use the left vertical axis to count the number of products in each of the price categories designated along the horizontal axis. Count how many different products (SKUs/PLUs) there are in each price category, NOT the quantity of each product.

4. Connect the tops of the counts in each column to graphically depict the distribution of retail prices.

STORE

DAILY DATA RECORD

Initials ———— Day of the Week ———————— Date ————

Dollar Sales and Number of Transactions

	$ Sales	Trans.	Weather and/or other conditions
Noon	————	————	————————————
3:00 PM	————	————	————————————
Closing	————	————	————————————
Additional	————	————	————————————
TOTALS	A $	B	Total Units Sold C

Primary Sales Staff On Duty

Open to Noon	————————————————————
Noon to 3:00 PM	————————————————————
3:00 PM to Closing	————————————————————
Additional	————————————————————

TOTAL Salesperson (Paid and Volunteer) Hours Worked D

Miscellaneous Information (Holidays, Special Events, Vacation Periods, Visiting Groups, etc.)

Additional Statistics and Calculations

Visitor Count		E	Ave. Units per Trans.		(C÷B)
Average Sale	$	(A÷B)	Capture Rate	%	(B÷E)
$ Sales per Visitor	$	(A÷E)	Trans. per Salesperson Hour		(B÷D)

Form 3: Daily Store Record. This form essentially captures non-financial information that is used to calculate some critical metrics that are benchmarks in the museum store industry, along with subjective and personnel data that will help to understand the day's retail activity and results. While the form can be completed by hand, converting it to an electronic spreadsheet would be the most efficient way to make calculations, search the history and populate the following Monthly and Yearly Data Summaries. The form should be completed contemporaneously, not held to be completed later.

STORE
MONTHLY DATA SUMMARY

MONTH _____

DATE	DAY of WEEK	A $ SALES	B TRANS.	C UNITS SOLD	D HOURS WORKED	E VISITOR COUNT	AVE. UNITS /TRANS	AVE. SALE	CAP. RATE	$ SALES /VISITOR	TRANS /HOUR
1		$						$	%	$	
2		$						$	%	$	
3		$						$	%	$	
4		$						$	%	$	
5		$						$	%	$	
6		$						$	%	$	
7		$						$	%	$	
8		$						$	%	$	
9		$						$	%	$	
10		$						$	%	$	
11		$						$	%	$	
12		$						$	%	$	
13		$						$	%	$	
14		$						$	%	$	
15		$						$	%	$	
16		$						$	%	$	
17		$						$	%	$	
18		$						$	%	$	
19		$						$	%	$	
20		$						$	%	$	
21		$						$	%	$	
22		$						$	%	$	
23		$						$	%	$	
24		$						$	%	$	
25		$						$	%	$	
26		$						$	%	$	
27		$						$	%	$	
28		$						$	%	$	
29		$						$	%	$	
30		$						$	%	$	
31		$						$	%	$	
TOT/AVE		$						$	%	$	

Form 4: Monthly Data Summary. This form is a summary of the data collected and calculations made on the Daily Store Record. No new data is collected or calculations required other than for the month-end line at the bottom of the page.

STORE

YEARLY DATA SUMMARY

YEAR _____

MONTH	A $ SALES	B TRANS.	C UNITS SOLD	D HOURS WORKED	E VISITOR COUNT	AVE UNITS /TRANS	AVE. SALE	CAP. RATE	$ SALES /VISITOR	TRANS. /HOUR
JAN	$						$	%	$	
FEB	$						$	%	$	
MAR	$						$	%	$	
APR	$						$	%	$	
MAY	$						$	%	$	
JUN	$						$	%	$	
JUL	$						$	%	$	
AUG	$						$	%	$	
SEP	$						$	%	$	
OCT	$						$	%	$	
NOV	$						$	%	$	
DEC	$						$	%	$	

YEAR _____

MONTH	A $ SALES	B TRANS.	C UNITS SOLD	D HOURS WORKED	E VISITOR COUNT	AVE UNITS /TRANS	AVE. SALE	CAP. RATE	$ SALES /VISITOR	TRANS. /HOUR
JAN	$						$	%	$	
FEB	$						$	%	$	
MAR	$						$	%	$	
APR	$						$	%	$	
MAY	$						$	%	$	
JUN	$						$	%	$	
JUL	$						$	%	$	
AUG	$						$	%	$	
SEP	$						$	%	$	
OCT	$						$	%	$	
NOV	$						$	%	$	
DEC	$						$	%	$	

Form 5: Yearly Data Summary. This form is a summary of the data collected and the calculations made on the Monthly Data Summary. No new data is collected or calculations made for this form.

About Andrew Andoniadis

Since 1992, Andrew Andoniadis has specialized in enhancing the profits of museum stores through his consulting services and programs. He has consulted with museums of all types and sizes, cultural and interpretive centers, botanical gardens and arboreta, historic sites and libraries and has been a featured seminar presenter throughout the United States and Canada, and in Europe and Australia.

Andrew's recent clients include:

- American Civil War Center at Historic Tredegar
- Amon Carter Museum of American Art
- Anchorage Museum at Rasmuson Center
- Audubon National Wildlife Refuge
- Crystal Bridges Museum of American Art
- Denver Art Museum
- Greensboro Historical Museum
- International Civil Rights Center and Museum
- LA Plaza de Cultura y Artes
- Maryhill Museum of Art
- Matthaei Botanical Gardens and Nichols Arboretum
- Museum of the Great Plains
- Nicholas Conservatory
- Santa Barbara Museum of Natural History
- Seminole Tribe of Florida Ah-Tah-Thi-Ki Museum
- University of Michigan Natural History Exhibit Museum
- VanDusen Botanical Garden
- Washington State Heritage Center
- Wisconsin Historical Museum

- Wisconsin Veterans Museum
- Yew Dell Gardens

Andrew's company, Andoniadis Retail Services, has recently launched a new service for museums outside North America who have significant numbers of North American visitors. The service focuses on enabling museums to deliver the level and style of merchandising, display, customer service and tactile experience generally favored by North Americans. The goal is to increase museum store revenue and visitor satisfaction for museums hosting North American visitors.

Andrew first worked in retail at age twelve pushing a broom in the back room of a men's clothing store in Deerfield, Illinois. He continued to work in retail through graduate school. In 1985 he developed the first retail store for Smith & Hawken, the nationwide marketer of fine quality gardening implements. Later, he co-founded Quinby's, a California based children's book, and arts and crafts store, that was sold to members of the Disney family in 1989. Twice Andrew has been able to take a year off to travel. Visits to museum stores around the world have added to the depth of ideas drawn on for current clients.

In addition to consulting, Andrew designs stores, and conducts store profitability reviews and on-site customer service and selling workshops. He also publishes the *Profitable Times*™ newsletter, available on his web site, www.museumstoreconsult.com, in which he has written about every aspect of museum store retailing. Andrew is the

Technical Editor for the *Retail Business Kit for Dummies* book, and is a regular contributor to *Museum Store* magazine and other periodicals. He has trained, motivated, and managed volunteers and employees for a wide range of sales, buying and administrative responsibilities. He is also a winner of the Museum Store Association's Service Award.

Andrew Andoniadis
Andoniadis Retail Services
Andrew@MuseumStoreConsult.com
http://www.MuseumStoreConsult.com
Voice & Fax: (international code) 503.629.9279

Also from MuseumsEtc

Alive To Change: Successful Museum Retailing

Leading international museum and gallery retail professionals
from the USA, UK and Europe share the secrets of their success
in this highly practical series of essays. The themes addressed
include such critical issues as ethical retailing, eRetailing,
increasing visitor spend, building your brand and trends for
the future of museum retailing.

Contributors include:
Gregory Krum, Cooper-Hewitt Museum, New York City
Louisa Adkins, Compton Verney, Warwickshire
Michael Whitworth, Manchester Museum
Michael Walton, London Transport Museum
Jeremy Ensor, Natural History Museum, London
Nuala McGourty, Royal Collection Enterprises, London
Aundrea Hollington, Historic Scotland, Edinburgh
Adam Thow, South Bank Centre, London
Ian Betterton, Dulwich Art Gallery, London
Simon Cronshaw, CultureLabel.com

ISBN: 978-0-9561943-3-6
Order online from www.museumsetc.com

Rethinking Learning: Museums and Young People

Practical, inspirational case studies from senior museum
and gallery professionals from Europe and the USA clearly
demonstrate the way in which imaginative, responsive services
for children and young people can have a transformational
effect on the museum and its visitor profile as a whole.

Authors recount how, for example – as a direct result of their
focus on young people – attendance has increased by 60% in
three years; membership has reached record levels; and repeat
visits have grown from 30% to 50%. Many of the environments
in which these services operate are particularly challenging:
city areas where 160 different languages are spoken; a remote
location whose typical visitor has to travel 80 miles; the
museum which targets children with challenging physical,
mental or behavioural needs.

This is an essential book not only for those working with
children and young people, but for those in any way concerned
with museum and gallery policy, strategy, marketing and
growth.

ISBN: 978-0-9561943-0-5
Order online from www.museumsetc.com

Creating Bonds: Marketing Museums

Marketing professionals working in and with museums and galleries throughout the UK, USA and beyond, share their latest insights and experiences of involving and speaking to a wide range of constituencies. Their practical, insightful essays span the development and management of the museum brand; successful marketing initiatives within both the small museum and the large national museum environment; and the ways in which specific market sectors – both young and old – can be effectively targeted.

Contributors include: Amy Nelson, University of Kentucky Art Museum; Aundrea Hollington, Historic Scotland; Adam Lumb, Museums Sheffield; Bruno Bahunek, Museum of Contemporary Art, Zagreb; Claire Ingham, London Transport Museum; Kate Knowles, Dulwich Picture Gallery; Danielle Chidlow, National Gallery; Margot Wallace, Columbia College; Rachel Collins, Wellcome Collection; Sian Walters, National Museum Wales; Gina Koutsika, Tate; Alex Gates, North Berrien Historical Museum.

ISBN: 978-0-9561943-1-2
Order online from www.museumsetc.com

Narratives of Community:
Museums and Ethnicity

Edited by Dr Olivia Guntarik, RMIT University,
Melbourne, Australia

In this groundbreaking book, cultural theorist and historian
Olivia Guntarik brings together a collection of essays on the
revolutionary roles museums across the world perform to
represent communities. She highlights a fundamental shift
taking place in 21st century museums: how they confront
existing assumptions about people, and the pioneering ways
they work with communities to narrate oral histories, tell
ancestral stories and keep memories from the past alive.

The philosophical thread woven through each essay expresses
a rejection of popular claims that minority people are
necessarily silent, neglected and ignorant of the processes of
representation. This book showcases new ways of thinking
about contemporary museums as spaces of dialogue,
collaboration and storytelling. It acknowledges the radical
efforts many museums and communities make to actively
engage with and overthrow existing misconceptions on the
important subject of race and ethnicity.

ISBN: 978-1-907697-05-0 (paperback) | 978-1-907697-06-7
(hardback)
Order online from www.museumsetc.com

New Thinking: Rules for the (R)evolution of Museums

This new collection of essays by leading international museum practitioners focuses on the across-the-board innovations taking place in some of the world's most forward-thinking museums – and charts the new directions museums will need to take in today's increasingly challenging and competitive environment.

Among the twenty world-class organisations sharing their innovative experiences are:

- Canada Agriculture Museum
- Canadian Museum for Human Rights
- Conner Prairie Interactive History Park
- Cooper-Hewitt National Design Museum
- Imperial War Museum
- Liberty Science Center
- Miami Science Museum
- Museum of London
- National Museum of Denmark
- Royal Collection Enterprises
- Smithsonian American Art Museum
- Victoria & Albert Museum
- Wellcome Collection

ISBN: 978-0-9561943-9-8 (paperback) | 978-1-907697-04-3 (hardback)

Order online from www.museumsetc.com

Inspiring Action: Museums and Social Change

Fifteen leading museum and gallery professionals contribute inspiring, practical essays on the ways in which their institutions are responding to the new social challenges of the twenty-first century.

Drawing on pioneering international experience from the UK, USA, Australia and Africa, these experienced professionals explore the theory and the practice of building social inclusion in museum and gallery programmes.

Contributors include: Ronna Tulgan-Ostheimer, Clarke Art Institute; Manon Parry, National Library of Medicine; Gabriela Salgado, Tate Modern; Katy Archer, NCCL Galleries of Justice; Peter Armstrong, Royal Armouries; Keith Cima, Tower of London; Olivia Guntarik, RMIT University; Elizabeth Wood, IUPUI School of Education; Gareth Knapman, Museum Victoria; Jennifer Scott, Weeksville Heritage; Susan Ghosh, Dulwich Picture Gallery; Jo Woolley, MLA; Marcia Zerivitz, Jewish Museum of Florida; Carol Brown, University of KwaZulu-Natal; Eithne Nightingale, V&A Museum.

ISBN: 978-0-9561943-1-2

Order online from www.museumsetc.com

Science Exhibitions: Curation and Design
Science Exhibitions: Communication and Evaluation

Edited by Dr Anastasia Filippoupoliti
Lecturer in Museum Education,
Democritus University of Thrace, Greece

These exciting new books examine how best to disseminate science to the public through a variety of new and traditional media. With over 40 essays from leading practitioners in the field, and over 1000 pages, they provide an authoritative, stimulating overview of new, innovative and successful initiatives.

The essays draw on cutting-edge experience throughout the world, and include contributions from Australia, Canada, Greece, Italy, Portugal and Mexico – as well as the UK and USA.

The authors examine the narratives generated in science exhibitions and tackle some of the challenges museums experience in transforming scientific concepts or events into three-dimensional exhibits.

ISBN: 978-0-9561943-5-0 and 978-0-9561943-8-1
Order online from www.museumsetc.com

Published by
MuseumsEtc
8 Albany Street
Edinburgh EH1 3QB
United Kingdom
www.museumsetc.com

ISBN: 978-1-907697-00-5
British Library Cataloguing in Publication information available.

Typeset in Underware Dolly and Adobe Myriad Pro.

Breinigsville, PA USA
10 December 2010
251110BV00003B/10/P